Portrait painting

Overleaf
Portrait of an 83 year old woman Detail
Rembrandt Van Ryn (1606–69)
National Gallery, London
This portrait is a mastery of tonal relationships with hardly a false step. Its three-dimensional quality is increased by the extreme range of its tone, a range so great that any copyist could only achieve the darkest dark by the use of a modified black. In the area on the right where the reflected light is catching the cheek the paint is semi-transparent, the underpainting being used to modify the tone, and in some places becoming the tone. The rest is direct painting with a loaded brush and combines freedom of handling with great bravura. An analysis of the brush strokes which can be made easier with a black and white photograph of good quality, shows that Rembrandt used a rounded brush of ample proportion that was capable of expanding to more than 9 mm ($\frac{3}{8}$ in.) but could also taper to a point. On the left cheek one can discern in the original an area of hesitation and troubled paint, a most comforting observation to all those who believe that great masters never had to struggle for their mastery

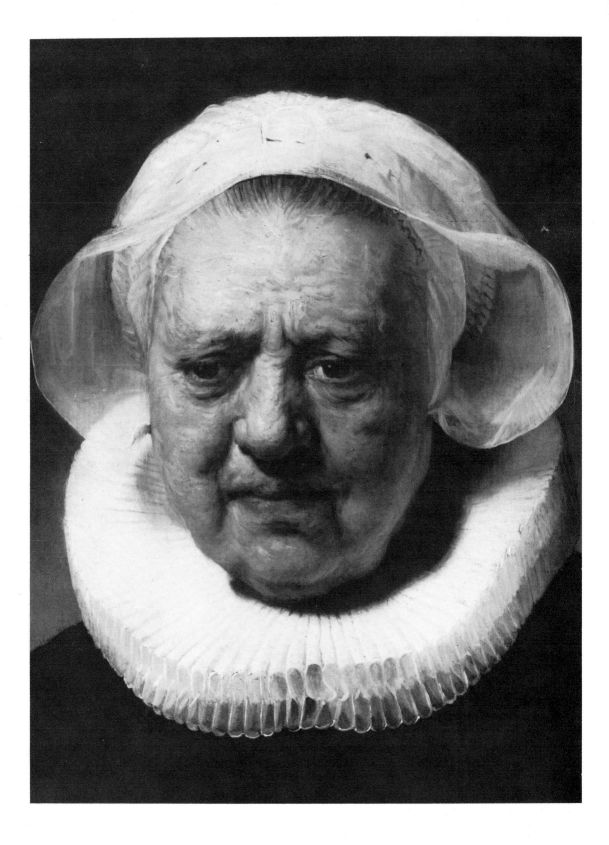

Portrait painting

Derek Chittock

B T Batsford Limited London

To JHC
and my students
past and present

© Derek Chittock 1979

ISBN 0 7134 3293 4
First published 1979

Filmset by Keyspools Ltd, Golborne, Lancs
Printed in Great Britain by
The Anchor Press Ltd,
Tiptree, Essex

for the publishers
B T Batsford Limited
4 Fitzhardinge Street
London W1H OAH

Contents

Acknowledgment

Introduction 6

The portrait as visual biography 7

Role of the portrait painter 9
 Use of objects and surroundings 9
 Unconscious comments 10
 Flattery, insult and license 11
 Social attitudes 11

Posing the sitter 15
 The single figure portrait 15
 The group portrait 16

The client 25

Colour, colour balance and the palette 29
 Complementary colours 30
 Colour balance 31
 The palette 32

Lighting the sitter 35
 Single source lighting 35
 Cross-lighting 35
 Lighting the features 35
 Lighting the background 36
 Spot lighting 36
 Studio lighting 37
 Low level lighting 37
 Surrounding colour 38
 Extra light 38
 Artificial light 38

Problems of the likeness 41
 The mouth 42
 The eyes 43
 The nose 44
 Ways of correcting the likeness 44

Portrait painting and photography 49
 Camera obscura 49
 Camera lucida 50
 Graphic telescope 50
 Daguerrotype 52
 Artists' views 52
 Practical use 52
 Photography and substitutes for nature 53
 The painter's dilemma 54
 A unique aid 54

Drawing, preparation and underpainting 61
 The imprimatura 62
 Underpainting 63

The alla prima stage 69
 Supremacy of drawing 70
 How to begin 70
 The half-tones and flesh tints 71
 Unusual optical effects 72
 Painting in the wet 73
 Highlights 76
 Sticking to a formula 77
 Value of raw umber 79
 The painter as physician 79
 Light and the anatomy of the eye 80
 The lower lid 80
 The hair and the forehead 80
 Final adjustments 84

Varnishing and hanging 114

Bibliography 116

Suppliers of materials and equipment 117

Index 118

Introduction

In this book I have attempted to cover almost every aspect of portrait painting, including a necessarily sketchy history. I have also attempted, on the basis of my experience of teaching students, to anticipate the problems which I know most frequently occur. Wherever possible I have tried to concentrate on facts and principles rather than value judgments with which the art world is already over-burdened. I hope the student will find of particular value the chapter on colour and colour balance in which I have tried to formulate, perhaps for the first time, a rational and scientific approach to the control of the palette based on the dialectical rôle of the complementaries.

The majority of reproductions have, where possible, been chosen to illustrate some point in the text. If I appear to have concentrated on some classical painters at the expense of others this is simply due to the fact that, with one or two exceptions, I have simply found their methods better documented, or the originals more accessible. The choice of contemporary portrait painters is to some extent arbitrary and is in no way a reflection on the many excellent painters omitted. The fact that most successful portrait painters look traditional is no doubt not an accident, for this is what their public expect. By the same token nobody survives as a portrait painter by accident. Those that have remained successful have done so by their ability over others, and more is the pity that in an art world of trendy gimmickry their respect for drawing and craftsmanship is too frequently overlooked by the media. If this book in a small way helps to adjust the balance it is an adjustment long overdue.

Finally, my thanks are due to the following: the Physics Department of the Science Museum for allowing me to photograph the drawing by Cornelius Varley, to all those who have provided me readily with prints and permission to reproduce them, and to Ros Sedergreen for help with the proof reading.

<div align="right">DC Sevenoaks 1979</div>

The portrait as visual biography

At first sight, and to the casual enquirer, it might seem that the portrait has always existed. In terms of the long span of art history, and the portable canvas or panel form by which we know it, it is a relatively late arrival. The Greeks and Romans produced portrait sculpture but few painted likenesses. The profile medallion portrait dates from classical times and helped determine the style of the first Renaissance portraits from which the full exploration of the human head on canvas was to begin.

A portrait might be described as a visual biography. Indeed it coincided almost exactly with the emergence of its literary counterpart. The first autobiography of moment was, coincidentally, the work of the colourful Florentine sculptor, Benvenuto Cellini, and it proved to be such a racy and compelling account of his life that it was to influence many novelists for centuries afterwards. At first the portrait did not appear as a separate entity but as part of a larger, and invariably religious, fresco. The innovation of including a portrait in a narrative mural was Giotto's and although now it scarcely seems even notable, in its day it was certainly a revolutionary step. The Peruzzi Chapel, built by the wealthy banking family, contains a Giotto fresco depicting the lives of the saints. The ornamental frieze of the fresco contains ten medallion portrait heads, almost certainly members of the Peruzzi family. The famous profile likeness of Dante by Giotto also occurs as a medallion in a frieze. The portrait, however, did not escape its medallion-like state until the richest families, who at the same time would be Church patrons, achieved a substantial degree of influence. In many of the early religious frescos, portraits of the donors appear in the narrative, as onlookers perhaps, but only as diminutive figures. Similarly, if donors appeared in altar-pieces, they would be diminished in size, but at least, as against a medallion in a frieze, they had entered the picture. Only later, when their wealth and power increased, did they achieve equality of scale with the sacred figures.

It was not until the fifteenth century in Italy and Flanders that the portrait gained its physical independence. Removed from its original religious context, its appearance points to a comparative secularisation of art. It is scarcely surprising that the portrait should emerge at a time when human initiative and resource were preparing for their greatest leap forward. The development of banking, trade and the woollen industry, based on the emerging entrepreneurial skills of the new merchants, were slowly spreading over Europe, bringing in their wake immense private fortunes and pride in achievement. It is appropriate that the visual exploration of human personality should be first concerned with those and their families whose wealth provided the means to command the artists' skill and encourage it.

In European art, wealth and portraiture have gone hand in hand. St Francis himself, the hero of many of Giotto's paintings, was against art because he was also against wealth. The English puritans too were

opposed to art because it was associated with aristocratic taste and the acquisition of worldly goods. Although Cromwell was painted, warts and all, his regime was responsible for the dispersal of many fine collections and in some cases the destruction of works of art. The use of the word 'deface' may have had its early baptism in the destruction of the heads of portrait sculpture and paintings considered as 'graven images'. Many English churches still bear witness to such a practice, which today would be considered as vandalism. The importance of the head is such that no equivalent word exists for the destruction of the body.

During the time of Leonardo da Vinci there was much disputation as to whether sculpture was a superior art to painting. The argument was inconclusive. Similar contemporary views are occasionally heard as to the superiority of literature to painting. Inasmuch as it affects a portrait as against a biography, the argument would run something like this. A biography can show a character growing and changing in time whereas a portrait freezes a particular moment, or time sequence, and is thus limited, or would require a series of portraits to do the person justice. Such arguments are really about the boundaries that each different art form imposes, and while they provide the most excellent debating material after a good dinner, the upshot must remain irresolvable. However, it is too tempting as a portrait painter not to put in my oar. There is in existence the most excellent film on the work of Rembrandt which ends by allowing all the Rembrandt self-portraits to dissolve slowly into each other in chronological sequence. It thus provides the extraordinary record of a man visibly changing and ageing before one's eyes and it remains a moving and compelling document in which a man's total physical existence and the ravages of time are compressed into three or four minutes of film. Portraits can therefore be made to unfold in time. Velasquez produced a fine record of the effect of time on his series of portraits of Philip IV of Spain. But I like to think that the really great portraits involve time by implication. That is they suggest a past, portray the present, and hint at the future. One would need, for example, singular lack of imagination to account for the events leading to the dishevelled state of Mussorgsky as depicted in Repin's remarkable painting (facing page 72) and even the sitter's eventual outcome does not come as a surprise. Only its timing might be at issue. Moreover, I do not think this is an example of hindsight arrived at only after reading the details of Mussorgsky's life but something intrinsically built into that rheumy, blotchy countenance.

Finally, however allied the written biography is to the visual biography, both historically and in content, its limitation is precisely that it cannot ever adequately convey the subject's visual appearance. Nor should one expect it to. The weakness of the one art form is the strength of the other, and conversely.

Role of the portrait painter

It is interesting to speculate on the unusual role and function of the portrait painter. Undoubtedly a study of the portrait from the Renaissance onwards shows that he tries above all to be a chronicler of the facts. The selection of the facts can of course be influenced by the social climate, the school of painting to which the artist may subscribe, or by the patron's attitude to the facts (the area in which the painter so often parts company with his client). The kind of painter who always seems to epitomise an almost sacred approach to objectivity is Holbein, who appears the embodiment not only of the sober scientific datachment of the Reformation, but of all time. The facts of the face are austerely and dispassionately recorded, with the surroundings and artefacts of the sitter's life deemed of almost equal interest. *The Ambassadors* is a *tour de force* of the musical and mathematical instruments of the period and which is clearly intended to shed light on the cultural pursuits of these two gentlemen. Similar emphasis on the sitter's activities, this time strictly commercial, is to be seen in his portrait of the German merchant and member of the Hanseatic league (Georg Gisz) showing the scales and small objects used in his day-to-day business activities.

Holbein's introduction to the Court of Henry VIII produced a change in his approach. His earlier realism is lost in favour of a flatter, more decorative treatment with two-dimensional backgrounds. It is hard to known whether this was the direct pressure of courtly taste (Elizabeth I was known to insist on portraits that had few shadows on the face such as we see in Nicholas Hilliard) or whether Holbein was simply and naturally imbibing the atmosphere of courtly ideas.

Use of objects and surroundings

Holbein in his earlier inclusion of his sitters' life-impedimenta was merely continuing the Italian and Flemish traditions of using objects to explain to us what his subject considered important. Among the props we come across are bibles, beads, shells, rosaries, books and flowers as well as individual jewellery and sumptuous costumes and chairs. The background of a room and its accessories when used in a portrait can do much to describe to the spectator the sitter's taste or his station in life, like the elaborate setting in Van Eyck's *Arnolfini and his Wife* with its intricate chandelier. Thus before we begin to examine the psychology of the couple, as evinced by their portraits, the stage has been set to examine in detail their religious beliefs, their fondness of animals, their fine clothes and worldly possessions. Sometimes practising painters are baffled by the interpretations placed on the subject matter, or iconography, by art historians who seem to look for significance everywhere when painters know that many things may be included in a portrait by accident or merely because they took the fancy of the painter. There may be something in this. But, inescapably, nothing is likely to be included in a portrait that would convey a false impression. For example, I cannot imagine any nineteenth-century parson, nearly all of whom seem to have

had their portrait painted, wishing to be painted with a copy of Darwin's *Origin of the Species* clutched to his bosom even if the painter happened to find it by chance on the parson's table. Painters in general tend to reflect their sitters' tastes and beliefs and so the art historian's view is broadly speaking valid. Dutch painters actually moved in the social circles they portrayed. It would have been unthinkable that a client of Terborch would have commissioned Brouwer or Van Ostade to paint his portrait for they really did associate in smoking dens and would have been ill at ease in the world of Terborch's satin and frilly cuffs.

The portrait painter may show accurately the sitter's surroundings without difficulty and choose those that are most telling, and help to explain the sitter's life. But how right did he get the facts of the face? After the Daguerrotype was invented in the 1830s we can tell. The better painters were correct. Indeed many used the Daguerrotype to help obtain their likeness. Prior to that, however, we can only judge the resemblance where a sitter has been painted by more than one artist. Mrs Siddons, for example, was painted by at least four; Gainsborough, Reynolds, Sir Thomas Beechey and Lawrence. The four are certainly not strikingly similar in likeness and indeed could be portraits of sisters, a phenomenon which many professional portrait painters will recognise. This built-in bias and interpretation is almost inevitable and may be explained by the differing classical and romantic outlook respectively of each artist. For instance Reynolds calls his Mrs Siddons *The Tragic Muse* and shows her lost in thoughtful reverie; Gainsborough's version is chic, gorgeously attired with appropriate matinée idol profile emphasised.

Unconscious comments

Reynolds also provides an unusually interesting example of the way in which a high-minded portrait painter can allow unconscious bias of his sitter to enter into his deliberations. His portrait of Giuseppe Baretti emphasises his short-sightedness by painting him unflatteringly reading a book held closely to his face. I know of no other portrait that emphasises a physical disability in such a way under the guise that reading is a laudable activity. One is prompted to ask why it was necessary to show him reading at all. An explanation is possible in Barretti's relationship with the Thrale circle of whom Reynolds was a close and intimate member. Baretti was employed by the Thrale family as an Italian tutor and his bad humour only tolerated because he was an excellent teacher. He remained disliked not only by Mrs Thrale but by the majority of her literary circle. His ill-temper eventually landed him in Newgate prison. I would describe Reynolds's reaction to him in paint as factual but unsympathetic and it is hard to believe that he would have considered rendering one of his aristocratic clientele in such a way.

One cannot say whether this foray by Reynolds was deliberate or unconscious. But I am reminded of a portrait painted by a colleague of mine of one of his close friends. It hung for several years in his studio until one day a visitor looked at it and remarked, 'Who is that sly-looking fellow?'. The reaction of my colleague was of hurt consternation that he could possibly portray his friend in such a light. He removed it from the wall immediately in case it produced a similar reaction in others.

However, later events proved the painter's initial and unwitting comment had intuitive roots in reality. Their friendship ceased and the painting remains a mute reminder that a portrait painter's response may be at its most reliable at an unconscious and instinctive level, however clinical and detached he believes are his measurements of the face.

Flattery, insult and license

I have been forced frequently in the past to consider my own conscious and unconscious reaction to my sitter and in particular to the difference between flattery and insult. The French painter Rigaud expressed the problem of painting women thus: 'If I paint them as they are they do not think they have been painted beautiful enough; and if I flatter them too much they do not like themselves.' No doubt the idea that the human mind pants after a higher order of excellence and is not ordinarily satisfied with the distribution of things met within common life has helped to give the portrait painter some license. But in my view there is a distinction between flattery which produces a likeness beyond credibility and is thus utterly false, and that which emphasises the finest and best attributes. The former produces a situation which is out of the sitter's reach and is thus a lie; the latter says these qualities are there for you to live up to, even if you have to try a little harder. But this does take a constructive, even optimistic view of human nature. Gainsborough's portraits were such, for certainly while ethereal, they never presented an image entirely beyond attainment. Of course all art is a kind of lie. The words written on the frame of a large Turner landscape by a spectator, 'magnificent lie' were left there by the painter with evident approval. The nature of the lie revolves around the complex selection and omission, exaggeration and minimising of the information. As we have seen this process is not always conscious. But it can be and indeed sometimes has to be. Let me illustrate this with a practical example. I was asked to paint a portrait of a man who was about to retire and during the first half hour we chatted over coffee and I was struck by his benignity and amiability. We commenced the sitting and as his face began to relax I could scarcely believe the transformation this brought about. His mouth slowly changed into an inverted 'U' and his once kindly features in conversation now assumed the mien of a ferocious Genghis Khan. However, I had to make a conscious decision. This man's idea of relaxed composure, which is what I normally try to achieve in a portrait, was not typical. Indeed everything pointed to it being positively misleading. I battled for a very long time over the problem area, which was the mouth, for the man either smiled when his face lit up or relaxed and looked terrifying. The final result was a position of the mouth which it never normally arrived at except in passing. But it seemed to work.

Social attitudes

Unless one is painting mechanically, the portrait painter is constantly faced with conscious choices of this kind. What I have referred to as a constructive and optimistic view of a person can also be part of the social attitudes of the age. The eighteenth- and early nineteenth-century portraits reflect a belief in man and his grace and dignity. A

Mrs Siddons Thomas Gainsborough (1727–88) facing page
National Gallery, London
Gainsborough at his most splendid and posed three-quarters, one of his
favourite angles. Gainsborough frequently painted thinly, like water
colour, over areas of thicker paint. The hair and neck ribbon are painted
in this way. Something has gone very wrong with the perspective of the
hoops around the sleeve of the right forearm. Perhaps this was the work of
Gainsborough Dupont, the artist's nephew, who for a while worked as his
assistant. The portrait that produced the utterance 'Damn the nose, there
is no end to it!'

Mrs Siddons Detail *Sir William Beechey* (1753–1893)
National Portrait Gallery, London
Beechey was a successful contemporary of Sir Joshua Reynolds with
whom his work is often confused. However like most followers his work
was seldom as good. I have included this portrait solely so that readers
may judge how similar or dissimilar is the likeness with Gainsborough's
interpretation. Certainly Beechey does not seem to have taken such a
long view of the nose that bothered Gainsborough so much. Note how
tonal counter-change is introduced everywhere. Even the dagger point
becomes dark against light, while the hand and haft reverse

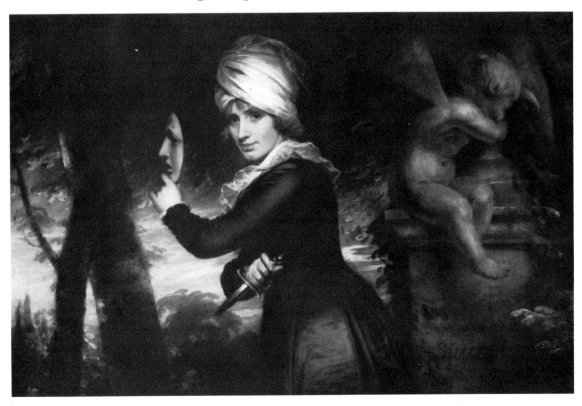

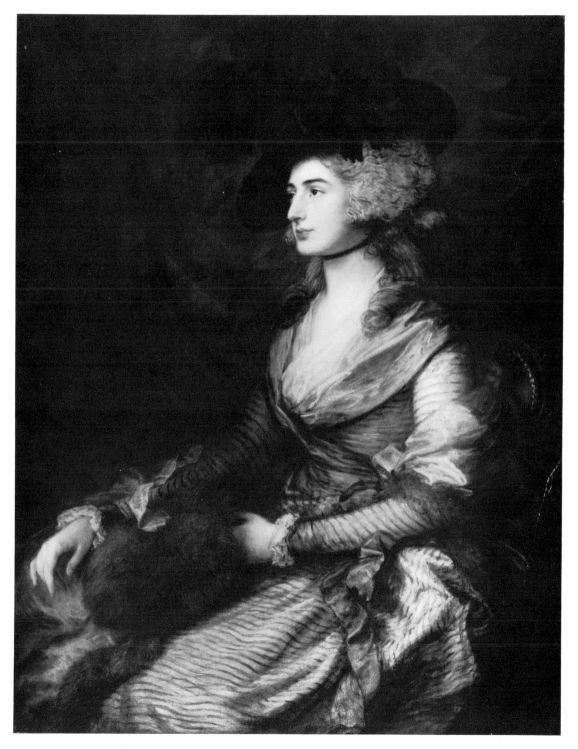

contemporary, Francis Bacon portrait, would of course have been totally unacceptable to an eighteenth-century Duchess of Devonshire or Sir George Beaumont. Bacon's paintings are not portraits at all in the normal sense. They are symbolic nightmares of our present human condition. They might be said therefore to act as warnings to the spectator. Cardinal Farnese by Titian is as near to saying 'rogue' in paint as any artist could manage without being put on the rack or garroted. The portrait's sense of villainy is reinforced by the knowledge that Farnese was involved in corruption and a poisoning scandal. Such a painting might well be construed as a 'warning' to the onlooker.

There are, not suprisingly, only a few portraits that appear deliberately satirical, although like Titian's Cardinal Farnese, they may appear critical of the sitter. Even Hogarth, who painted figures and faces satirically, never painted a satirical portrait. That of Lord Lovat comes closest to it. But Hogarth, who in his earlier life had pretentions to be a portrait painter, painted the group of his servants with great understanding and compassion. We are left to the group portrait of the Spanish Royal family by Goya, a row of lifeless and dumb effigies, for what appears to be a genuine touch of lampoon. But who is to say this is not what they were really like? A contemporary English painter, such as Ruskin Spear, undisguisedly employs portraiture as social comment on his sitters. One would expect these to be unsolicited and they are often worked from Press photographs.

If we now reconsider the initial question as to the nature of the portrait painter's function, we might summarise its permutations under the following headings. A *classical*, factual approach that might be said to hold a mirror up to nature and usually associated in European art with forward-looking and optimistic social periods; a *romantic* approach where the painter's personality becomes more obtrusive and which might suggest a restless yearning after an ideal, whether it is of society, beauty, or behaviour; a *critical* approach which could be seen as disapproval of the sitter, or his rank, or of his social attitudes of behaviour (a true critical portrait is rare and is inclined in comment to be artful rather than obvious); finally an approach which might serve as a *warning*. I am inclined to think this is only a semi-serious possibility. Nevertheless, I once drew a portrait of the late Tom Driberg during his early years as a Member of Parliament. He described the drawing as a 'warning'. Having read his posthumously published autobiography I think the drawing was probably right.

Posing the sitter

When one considers that the portrait painter has only one theme on which to ring his changes it needs no imagination to see how vital is an interesting pose and how easy it is to produce something so unexceptional that even the critics who write about art in newspapers will notice that it is dull. It is for this reason that the part played by lighting and the disposition of lights and darks should be emphasised, for these can enliven and transform even a head and shoulders that look squarely out of the canvas. If it is just a head and shoulders, in fact, there is little one can do to make it remarkable, although one of my favourite portraits is that of Gainsborough Dupont by Thomas Gainsborough, a mere head and neck and with a touch as felicitous as any painter ever achieved.

The single-figure portrait

The one cardinal rule I have with a single figure is that almost invariably the sitter himself will provide you with the idea. Most people will assume a pose that is natural and even characteristic of them almost immediately provided that they are not too self-conscious. If you are lucky it will only require a few minor adjustments and you are away. Even with successful and famous people it is not surprising if there is some degree of self-consciousness. Being scrutinised with such intentness is nobody's normal occupation and the only people who manage it easily in my experience are actors who in any case normally receive fees for being looked at. On one occasion only did I find the roles being reversed. I was painting a boy of about ten and he suddenly noticed that by dint of narrowing my eyes at him I kept frowning. Every time I did it he kept reporting to me how my forehead was behaving. I jokingly tied a handkerchief round my forehead for the rest of the sitting and there were no further problems. On another occassion a youthful sitter burst into tears and I had to abandon the sitting. But this was not due to being over-scrutinised. It was really because she had planned to go riding that morning and quite understandably did not want to be painted. To deal with sitters adequately means that the portrait painter must be fairly adept at social skills and also often has to keep the sitter interested or entertained. However, this is not an essential prerequisite for the portrait painter, provided he knows exactly what he wants from the sitter and knows how this is to be obtained. When Augustus John painted Montagu Norman, the then Governor of the Bank of England, it seems that hardly a word passed between them and no attempt by either man was made at serious communication. The man whose name was on every English banknote at the time, arrived in his chauffeur-driven Rolls at the appointed hour and departed when the sitting had finished as silently as he arrived. In my view something of their relationship has been permanently preserved in the painting.

It is usual and useful to put sitters at their ease, if you do not already know them, by talking for as long as seems right. However, I am frequently asked whether knowing a person well means that you paint them any

better and the short answer to that in my experience is no. Indeed it makes it more difficult, for all the underlying cross-currents of information could detract from the more general view which a painter has to take from the facts of the face. No portrait ever turns out exactly as you plan it and, in the final analysis, it is the instinctive reaction which seems to take over. Perhaps one day scientists will discover that our instincts are as much to do with the reception and transmuting of information as our senses. This has certainly been my experience.

The following general considerations will apply in posing a single figure. If the head is turned towards you it will inevitably turn away as the sitting progresses. It is best to stick to the original pose and not keep adjusting it. A head turned is, in my view, always more interesting. It is in the tradition of the Baroque and Romantic portrait and thus gives it the suggestion not only of movement but, when properly managed, an indefinable hint of restlessness and energy. This is a personal view for there are many magnificent portraits that are static and yet remain noble and fine heads. But the element of the yearning and unattainable, which touches on the mystery of the human personality yet exalts what it might become, is the basis of all great portraits. But as the reader will have noticed it is always easier to spin words about fine portraiture than to execute it!

When hands are involved the same rule applies, namely, that the sitter will normally provide the idea. However, hands are the one part of the anatomy which a sitter usually wishes he did not possess and try as you may it is often difficult for him to place them in a relaxed and natural way. Often a sitter will say, 'How do you want me?' I then experiment and if the hands are presenting a problem I suggest that they go through again in a more relaxed way the movement by which they arrived at the pose. This nearly always produces the desired result. However I have constantly to bear in mind the kind of background I am proposing to introduce, particularly as I am sometimes called upon to introduce the client's house and this usually requires a three-quarter view of the body, like an 'L', or an 'L' in reverse, for there is no other way of providing a gap for the horizon. Requests of this kind unfortunately do not leave much room for experiment. Occassionally one receives a strong even overpowering idea of how the sitter should pose, and appear in countenance. When this occurs I am inclined to brush all other considerations aside, houses as well, and there is usually little resistance in the face of well founded conviction. I am certainly not one who feels that an artist is always right. But when he feels he is he should not give way.

The group portrait

By far the most difficult of all poses to arrange are to be found in the group portrait. There are many good portrait painters that are not at their best in handling more than one person. The result is that many painters tend to specialise in groups and are chosen for commissions for this reason. What is required is an ability equivalent to that of a theatrical producer in which the painter has to write the plot, cast and pose his actors, and then become the sole executant. Not surprisingly, few have all these required talents. From the point of view of time, and in this case I mean

the sitter's time, I have found the camera the most useful short cut in the composing of a group. This gives one far more opportunity to ponder at leisure the advantages of one arrangement over another. One may also rearrange and substitute one figure for another by cutting out the figures like silhouettes to form fresh compositions. If you are fortunate you might arrive at your idea with sketches and without the camera as an aid. But I have often been pressurised in this way to commence compositions that I have later been unhappy about and have abandoned, with a subsequent loss of everybody's time. With groups of up to three and four figures the problems are naturally compounded. Even Van Dyck produced an occasional wooden-looking group. The English eighteenth-century painter Arthur Devis, much sought after in the auction room, was frequently a painter of family groups, but these have never been completely acceptable to me by reason of their quaint stiffness and despite the delicacy of their handling.

What a group portrait requires is a sense of theatre. The misnamed 'Night Watch' by Rembrandt has this. Many of Frans Hals's group portraits have it, although he has relied more on activity and less on light and shade. If one took Frith's 'Derby Day' as a whole series of group portraits, which in a sense it is, it is full of inventive plotting. Although its intention is different from portraiture its variety of pose and movement is precisely what is required in a group portrait and what is called in the 'in' jargon of the theatre, 'business'. 'Business' means devising means of achieving variety, holding the interest of the spectator with some simple activity or movement and without which the whole exercise would become mundane. Sometimes the simplest of devices such as the change of direction of the eyes, the toying with a prop or a favourite ploy, playing with an animal, all these are possible ways of demanding the spectator's attention. At all the costs sameness is to be avoided and variety of pose, angles, gestures, encouraged; but at the same time any obvious posing and theatricality is to be avoided. Theatricality in this instance means an obvious exaggeration such as we see in the work of Hogarth and which is designed to be satirical (eg the pose of the woman yawning in *Marriage à la Mode*) and which can be contrasted with the almost boring inactivity of an Arthur Devis group. Exaggeration is the license of all art. In principle one should be in favour of flamboyance rather than tameness, but in excess it can become auto-satirical.

Group portraiture is a specialist affair and is likely to be outside the experience of most students and even professional painters. In art history it has tended to be associated with specific periods, notably the height of the the Dutch and English schools.

Mr and Mrs Richard Harris and Family Derek Chittock

This painting was originally designed to include only the first four figures viewing from left to right. Subsequently I was asked if I could include the figure of Mr Harris on the extreme right. This was only possible by extending the area of the painting by some 15 cm (6 in.) which fortunately I was able to do as the support was of hardboard and not canvas. The extension was carried out for me by a picture restorer using block board on which to join the two pieces together. The join was then skilfully concealed and primed. My biggest problem was that of providing a composition of sufficient variety to hold the interest. It was fortuitous that the extra figure fitted in without throwing the design out of balance

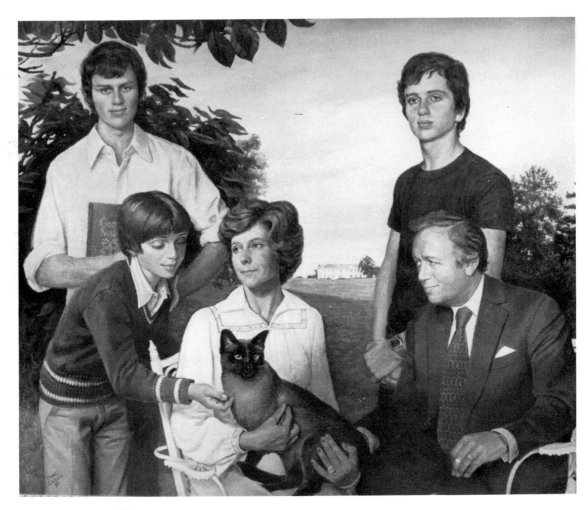

Head of Alexander Detail from family group opposite
The whole of this head was painted virtually in one sitting using a large
sable brush. However this would not have been possible without the
careful preliminary work of the raw umber underpainting which is
allowed to influence the modelling by the cheek and under the jaw

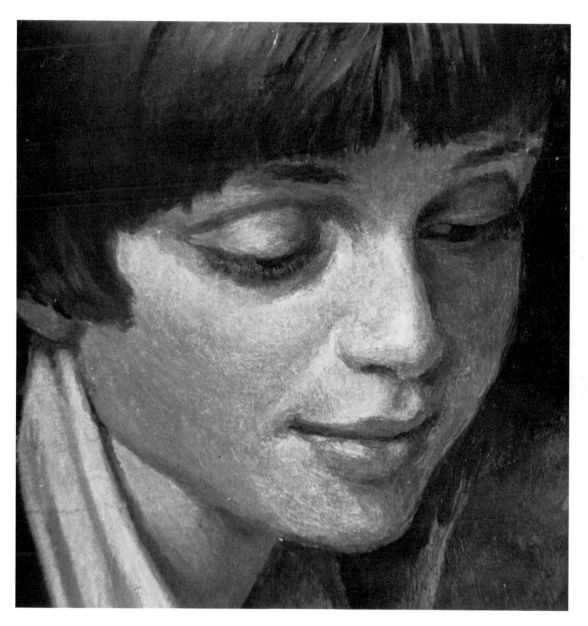

Overleaf
Detail on
facing page

Meeting of the Society of Dilletanti at the St James Club John Ward RA
This particularly fine group portrait, which was carried out in two
sections, was preceded by innumerable drawing studies of remarkable
quality. From these preparatory studies the final composition was
resolved and the drawings squared up and transferred to canvas. The
poses are natural yet full of variety and nowhere has the likeness and
characterisation of each individual been sacrificed for the total effect.
Much has been made of the light playing through the trees of Green Park
as seen through the windows of the St James Club. The colour harmonies
are particularly beautiful and well judged and the decorative qualities, so
difficult to establish in portraiture, have been carefully considered

Study for Dilletanti Group Chalk on tinted paper heightened with white
John Ward
Courtauld Institute of Art, London
One of the many preparatory drawings made for the painting. It shows
Mr Brinsley Ford in close up on the left and wearing the Secretary's robes
on the right. The pose as eventually arrived at has been modified and
reversed

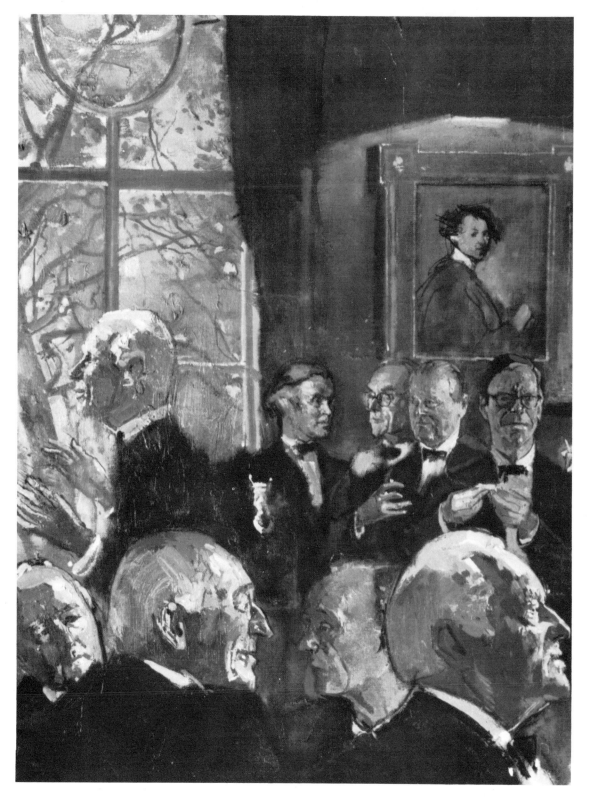

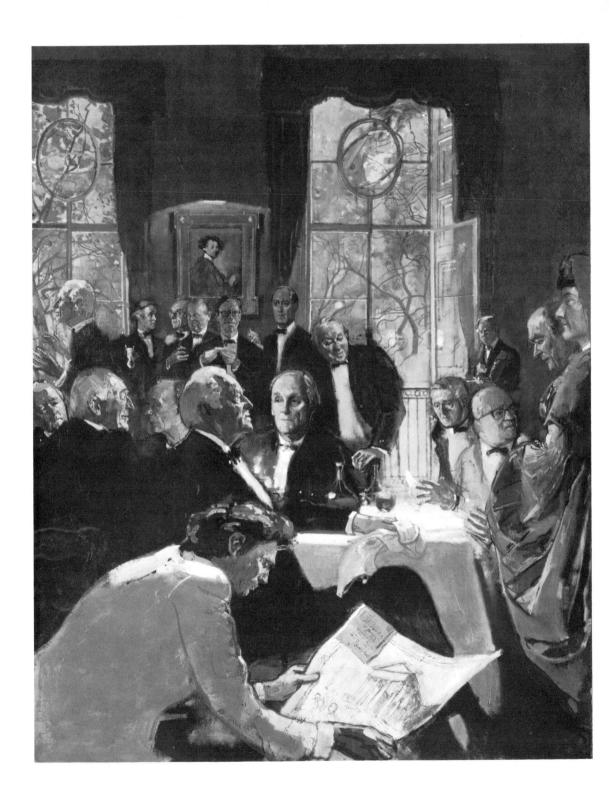

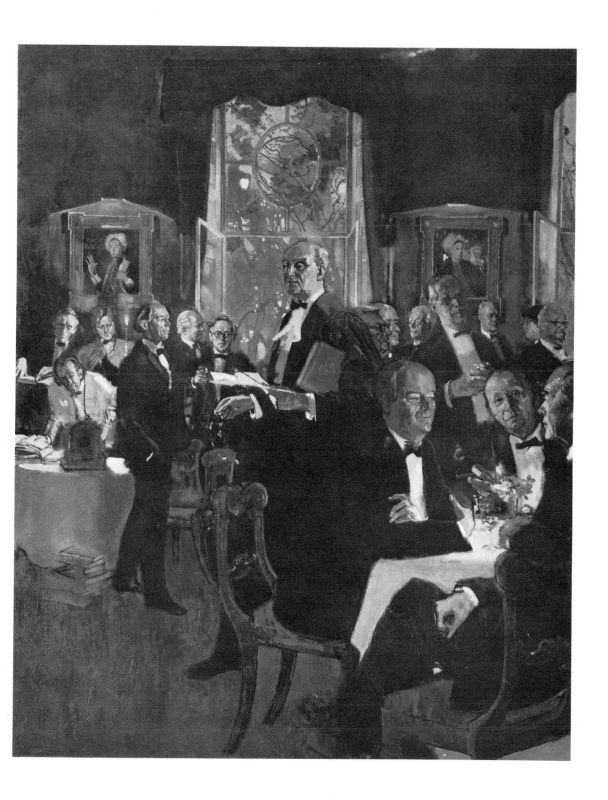

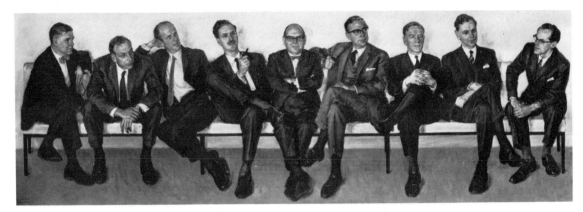

The London Business School's Academic Committee June Mendoza RP
June Mendoza is among the few successful women portrait painters of our time and is equally at home with single figures as with groups. Her *forte* lies not only with her fresh drawing and handling of paint but with the ease and inevitability with which she is able to pose her subjects, of which this unusual group of academics is a good example. A portrait painter must be strong in all departments. To survive is to be able to paint mens' suits well

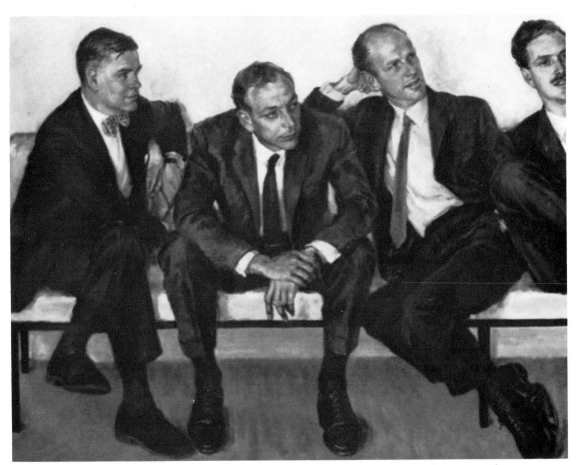

The Client

As the client of the painter may often, but not always, be the sitter, or perhaps intimately involved with the sitter, there may well be a strong temptation for him to offer advice, or otherwise intervene. Everybody is a back-seat driver of something. In chess they are called kibbitzers, onlookers who offer gratuitous advice. They can add colour and often wit to the game; but also fray tempers. In painting, tender temperaments can be easily upset by the spoken word and even sometimes by the word unspoken. A long silence after sight of the portrait can be more meaningful than a pointed remark and just as disturbing, particularly in a portrait which is only half-formed. Not that all long silences indicate disapproval; sometimes it may be quite to the contrary. However, it is not surprising that there is a tradition among painters that the portrait is not shown to the sitter or client until it is completed. The great J M W Turner when painting at Petsworth kept his room locked and would only allow his friend and patron to enter with a pre-arranged series of knocks on the door.

Many painters can be amiably disposed to the sitter wandering around and commenting on the proceedings. I can myself. The difficulty arises when familiarity encourages an increasing boldness of comment. Fortunately I have seldom, if ever, found myself in this situation. But most artists will find it easier if from the start they shy away from allowing such a situation to develop. It is different when the portrait has been completed. To hear the various aspects of the sitter's character that you have caught and how they resemble this, or that side of the family, is often the most interesting part of the operation. Nevertheless, you can expect to receive criticism of the likeness from time to time and my attitude to this is to consider whether it is reasonable or unreasonable. It must be said that on this particular issue the painter may not always be right and he should always listen to just comment. The painter Oswald Birley, whose portrait of Mellon hangs in the National Gallery of Washington, is said to have had a housekeeper who always gave final approval of the likeness before he allowed it to be seen, although she had never painted herself. It may be necessary to balance any slight alterations with the corresponding loss of spontaneity this might produce. I have found that this explanation to alteration is nearly always acceptable, provided the objections are not too deep-rooted. The finest portrait painters had problems with the likeness and it has not always been amicable as the following disagreement between a merchant and Rembrandt shows:

> Today, begin the twentythird of February, 1654 I, Adriaen Lock, notary, went, at the request of the Portuguese merchant, Sir Diego d'Andrada, from here (Amsterdam) to see the painter Sir (*sic*) Rembrandt van Rijn, to announce the following: The aforementioned Accuser says that some time ago he commisioned you the Accused, to paint a certain young maiden and that he gave you for this a down payment of 75 guilders, and agreed to pay the rest on completion of the painting. Now the Accuser finds the aforementioned portrait does not at all resemble the face of the young maiden, and the Accuser lets the Accused know, by notary, that he must

alter the portrait before the departure of the aforementioned young maiden, and make it into a true likeness. In default of his doing this, he wants him to keep the painting because he has no use for it, but in that case demands the restitution of the money paid in advance.

When all this had been read to the Accused, he (Rembrandt) answered: That he would not touch or complete the painting until the Accused had paid him the rest of the money, or given him satisfaction. When that has been done, he will complete the painting and submit to the judgement of the heads of the Guild of St. Lucas the question whether or not it resembles the maiden; and if they decide that it does not look like the maiden, he will alter it. And if the Accuser is not satisfied by this some day he (Rembrandt) will complete it and will offer it for sale, the next time he has an auction of his paintings.[1]

Imagine someone not wanting a Rembrandt, even half finished! I can only think the descendents of Sir Diego d'Andrada never forgave him. The following letter written by Thomas Gainsborough represents a more gentlemanly difference, with the problem of the likeness still the central issue:

To the Earl of Dartmouth
My Lord,
I rec'd the honour of your Lordship's letter acquainting me that I am to expect Lady Dartmouth's picture at Bath, but it is not yet arrived – I shall be extremely willing to make any alterations your Lordship shall require, when her Ladyship comes to Bath for that purpose, as I cannot (without taking away the likeness) touch it unless from life. . . . I never was far from my mark, but I was able before I pulled the trigger to see the cause of my missing and nothing is so common with me as to give up my own sight in my Painting Room rather than hazard giving offence to my best Customers. You see, my Lord, I can speak plainly when there is no danger of having my bones broken, and if your Lordship encourages my giving still a free opinion upon the matter, I will do it in another Line. I am your Lordships most obliged and obedient humble servant

THO. GAINSBOROUGH

Bath April 8th 1771[2]

The bulk of what I have omitted from this letter concerns Gainsborough's contention that placing Lady Dartmouth in fancy dress (a common eighteenth-century practice) had taken away the likeness and what was required to correct it was to put her in modern costume. However, in the final count Gainsborough was prepared to repaint the portrait if this failed to please. His ensuing letters to Lord Dartmouth are full of sly wit and winsomeness and it was clear that Gainsborough was not prepared to give way easily; although the letters are couched in the extravagant politeness of the time Gainsborough remains conscious of his independence while outwardly appearing flexible.

An unusual and possibly unique event occurred in 1978 when it was revealed that Lady Churchill had destroyed the portrait of Sir Winston Churchill by Graham Sutherland. In this instance the portrait had not

[1] Quoted in Literary Sources of Art History, ed Elizabeth Holt. 'Sir' is possibly a mistranslation of Herr.

[2] The Letters of Thomas Gainsborough, Lion and Unicorn Press 1961.

been commissioned by the recipient but by the House of Commons and the offence the portrait gave (long suspected during the lifetime of both Sir Winston and Lady Churchill) did not revolve around the likeness so much as the interpretation. This is not the place to summarise the pros and cons of the attitudes this extraordinary act aroused in British breasts. But it underlines the importance of the client making the right, or relatively right, choice of painter. In this particular case the choice was that of a committee headed by Aneurin Bevan who must have been aware of Sir Winston's strongly held views on art matters. A maladroit choice of portrait painter might be considered an ingenious way of working off an old political score, since any mischievous motive could never be proved. Anybody familiar with the problems of portrait painting at the time, and of the importance of matching sitter with painter, might have had good reason to anticipate such a rumpus. In painting a portrait the artist and sitter are temporarily involved in a marriage.

William Wilberforce Thomas Lawrence RA (1769–1830) Detail
National Portrait Gallery, London
This interesting unfinished painting of the leader of the anti-slavery
movement shows clearly Thomas Lawrence's method of commencing a
portrait. For a fuller account of this portrait see page 65

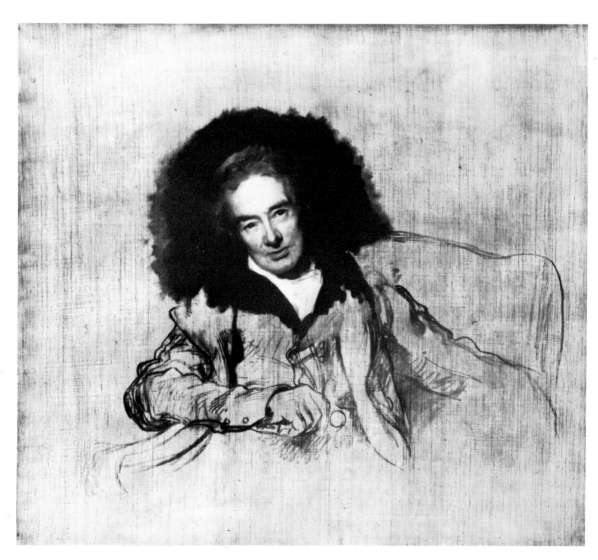

Colour, colour balance and the palette

Drawing may be the probity of art as Ingres said, but it would be a profound mistake to think that drawing alone will get a portrait painter to his goal. If he cannot control his colour he will make little progress as a painter. Colour control means seeing a colour and tone and being able to reproduce it. At a later stage it may mean exaggerating, strengthening, or neutralising a colour. But this cannot be done until, in the first instance, you can mix the colour and tone you can see.

The first priority is to become acquainted with a range of colours so that you know precisely what they are and how they behave. For this purpose it is necessary to know about their properties, ie their intrinsic hue; their intensity; their tone and degree of transparency or opacity. I have included a list which is intended as a guide to determine these properties. With a portrait it is best to work with colours whose intensity or brightness* roughly correspond to your subject. These will tend to be modest and simple colours but do not be deceived by their lack of assumption. The greatest portraits were painted with but few colours. Hals and Rembrandt used no more than four to five pigments for the flesh. The Romney self-portrait could be reproduced exactly with four colours: black, yellow ochre, white and a colour similar to light red. In the case of Hals, and possibly Rembrandt, one should add raw umber to that list. However, a colour virtually identical to raw umber can be provided by mixing together black, ochre and white in appropriate proportions. Thus a head can be painted well with four pigments and I normally make a special point of using only these when giving a portrait demonstration. I do this solely to show that the important aspect of flesh painting is the play of warm and cool colour and that this can be achieved with the most economical means using white, ochre, light red and black (which most people are surprised to find behaves as a low intensity blue). However, a palette such as this would place limitations in the rendering of flesh tints in the direction of pinks and mauve reds in the case of some complexions. Its range therefore should be increased by the addition of a vermilion and Indian red (which is slightly mauve) although some artists might prefer alizarin crimson. However, the latter is an extremely fierce colour and while the student is feeling his or her way it might be preferable not to use it.

It should be said that yellows stronger or more intense than ochre, such as chrome, lemon or cadmium yellows are nearly always mishandled except in experienced hands and are normally unnecessary, except as an occasional reinforcement to the ochre, in flesh which is in a very strong light or high key. Such intense hues may well be necessary as local colour in costume or some part of the enviroment of the portraits, as would ultramarine or some other intense blue, together with viridian, that most powerful and inimitable green. However, it is to the flesh that our complete attention is turned. The single problem of using colour in a correct (ie objective) way is simply posed. It is of taking a local colour and

*Scientists use the word chroma when describing a colour's brightness. Chroma is scientifically measurable.

29

being able to turn that colour into shadow. Put that simply, one wonders why there are any problems at all. The first, and not unreasonable reaction of the beginner is to use the purer form of the colour if it is dark, for the shadow areas, and to lighten it by adding white. Or conversely if it is a light colour, to add black to it to make it darker. To follow why the matter is not so simple it is necessary to analyse what precisely happens when something turns into shadow. Shadow means lack of light, or a decrease in light. It is a physiological condition of the human eye that it is less able to perceive colour as light decreases. The eye is made up of hundreds of cones and it is the cones that are concerned with colour. These cease to function properly in dim light. You can test this easily in moonlight by seeing if you can determine the colour of the trees. It is virtually impossible although the light might be good enough to enable you to see your way about. What happens to a bright or intense colour in shadow is that its intensity goes on decreasing as the lack of light increases. We might now put the problem in a different way. How is it possible not only to make a colour darker in tone but also to decrease its intensity? The simplistic solutions of adding larger amounts of the same colour can indeed darken the colour's tone; but they will usually increase its intensity. For instance cadmium red is much brighter in its pure state than when white is added to it. There are a few colours, such as alizarin, where the addition of white seems to increase its intensity. But even so, in its pure form, it would remain far too intense to use as a shadow.

Complementary colours
Fortunately, there is a ready expedient for the problem and it amounts to a guiding principle. All colours can be reduced in intensity by the addition of their complementary. Or, alternatively, if it happens to be a primary colour, by the addition of the other two primaries. In the case of a primary colour, such as blue, it becomes a relatively simple matter of finding an orange tint of the right tone to mix with it. If a deep tone were required it would be necessary to add burnt umber, that being the nearest to a low key orange.

As flesh is a complex local colour it is more difficult to find the complementary colour which will reduce its colour intensity as it turns into shadow. In mixing a flesh tint we are using more red than ochre so we can expect that it will assume a greenish cast in shadow. In practice it frequently appears as a green-grey, an olive colour, and it is often particularly apparent under the lower jaw. The correct thermal balance of this green-grey is of great importance for without it the flesh colour will not come alive; properly arrived at it will give a heightening value to the pink as, in turn, the pink will complement the green-grey. So we can now see that flesh cannot be arrived at in shadow as though it were a descending series of pink tones which would only make it monochromatic and dead. In the chapter on *alla prima* painting you will see that Thomas Sully anticipated this flesh shadow with three gradated admixtures of raw umber and white and this is certainly a workable formula, but it can also be arrived at with black and ochre (which produce a dull green) and then thermally or tonally modified with white.

The effect of the reduction of colour intensity by the use of a

complementary means that in shadow every hue is thermally changed. Red, by the addition of green, will become cooler; green will become warmer. This may be taken therefore as a law and the great value to the painter, moving constantly in a world of uncertainty, is that for once an effect can be predicted. However, nothing is a substitute for proper observation, and the reflected light from the environment of the head must always be taken into account. It is the commonest occurrence for a shirt or dress to throw a reflection under the chin and this will naturally destroy or modify the complementary effect.

Where there has not been proper regard to the principles I have described above, the head will tend to look cut out and separate from its surroundings in the manner of a montage.

Colour balance

The following general points regarding colour in the head may be noted. All dark areas that are enclosed by skin or mucous membrane should be kept warm and their warmth can be safely exaggerated. I have seen students struggling to identify the nature of the dark colour inside a nostril, or an ear. Like a highlight it occupies such a small point that it is difficult to analyse. It is precisely in such a situation that general principles are a useful guide. All dark shadows, as I have argued in the chapter on underpainting, are inclined to warmth; this would apply even more when two warm areas laced with blood and capillaries are facing each other, such as inside a nostril or mouth. This principle would also apply to the tone where, say, two fingers meet together or a hand is pressed to the face. It might also apply to the shadow that is often cast by the wing of the nostril, but this might receive in-filling from another light source. It is a good idea to enhance in colour terms very slightly the complementary, and therefore typical, thermal behaviour of colour. The flesh tint therefore, provided it is adequately compensated with its cool counterpart, may be slightly exaggerated. Boucher's flesh tints often seem wildly exaggerated and pink. But at a distance they appear right. This may well be the reason that stage make-up is employed in the theatre for strong light makes all complexions appear drained of colour; light in which the portrait might hang, could also bleach colour, and make the recipient look pale.

Excessive subtlety should be avoided if it loses track of the main tone or colour area or the total effect. If it were true subtlety no doubt it would work; but so often the attempt to see and analyse colour changes in the face begins to look like Jacob's coat of many colours and completely loses track of the need to keep the main light areas warm and the shadow areas cool.

Note that small areas of neutral tint take on an entirely different cast depending on the surrounding colour. In general a neutral tint surrounded by a strong local colour will assume the latter's complementary (see the argument in the *alla prima* chapter on the colour of the highlight, page 76). Finally, if you are in genuine doubt about a deep shadow area that you cannot analyse, and the study of the principles above do not lead you to a theoretical conclusion, then use raw umber. It may not be precisely right but it seldom looks completely wrong!

The palette

A great deal of curiosity surrounds the palette an artist uses and this is evinced by surviving examples that are placed under glass cases in National Galleries and Museums. The practice of laying out colour on a palette varies so much from artist to artist that almost everyone works out an individual solution. In my experience this can range from the chaotic to the almost obsessively methodical. The only reasonable test in the end is what happens on the canvas from each approach. If you are looking for a general guide it is perhaps a good idea to separate the cool and warm side of the palette. The only practical hint which I have found extremely useful, is to provide several mounds of flake (or titanium) white. As white is the colour that is most used one mound alone will invariably become stained with many colours. My own practice veers from order to disorder in the arrangement on my palette, but I stick to mixing ample mounds of colour using a palette knife. Without this it is impossible to work freely and surely. Constant re-mixing has its attendant danger of never quite hitting the same tone or tint and wasting precious time. Good mounds of colour might also persuade the student always to keep his brush loaded with colour, failure to do so being the most persistent fault that plagues the beginner. As Rembrandt is said to have replied to someone who mentioned that because of the thickness of its paint a portrait of his could be picked up by its nose, 'Sir, I am a painter, not a stainer!'.

Short colour list in descending order of tone and intensity unless otherwise stated

Yellows	Lemon yellow Chrome Cadmium Ochre Raw Siena Raw umber	Naples yellow is high in tone but weak in intensity
Reds	Vermilion Cadmium Light red Burnt siena Burnt umber	Alizarin red is low in tone (has a violet cast) but is of high intensity (not a true descending red)
Blues	Cerulean Prussian Ultramarine Black	(greenish cast) (may be considered as a very low key blue in certain circumstances)
Green	Terre vert Viridian	Tonally similar to terre vert but of high intensity

Portrait of Mme Manet Edouard Manet (1832–83)
National Gallery, Oslo
A spirited Manet painted in 1876 when placing the portrait in only half
the canvas must have seemed a radical departure. The flowers and leaves
produce a decorative and busy accompaniment to the main theme and
are handled with great bravura. Manet's debt to Velasquez is evident in
the treatment of the hands and sleeves as well as certain other passages in
the background. Like Velasquez, Manet made much use of the much
maligned colour black, the studied avoidance of which has almost
developed into a modern superstition

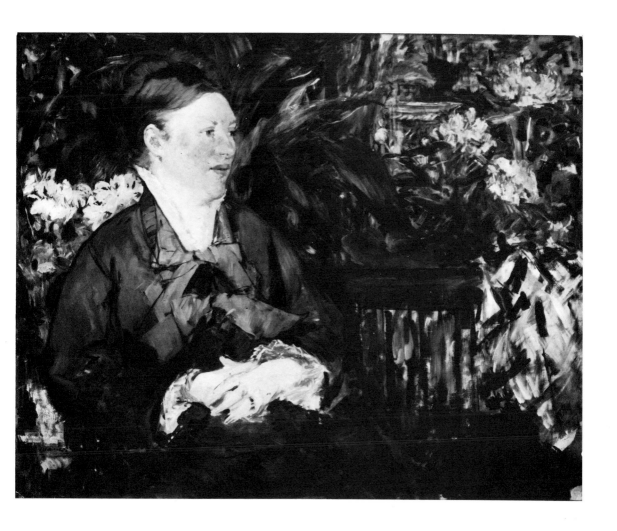

Sir George Porter FRS Bernard Dunstan RA

Bernard Dunstan is a painter of intimate interiors with a sensitive eye for composition and the subtle play of light. He is also a master at the orchestration of colour in the broken touch manner of the Impressionists. This catches him unexpectedly as an 'official' portraitist, but in which he has preserved his interest in the total environment. The play of light from the lamp has become an integral art of the portrait. Dunstan is not only a fine painter but also one of our best essayists on painting matters. His approach is scholarly, but unlike an orthodox art historian, he is able to bring to bear in his writing an immense practical experience as a painter. This is a rare combination of abilities to which we must turn to the nineteenth century for precedents. His *Painting Methods of the Impressionists* (Watson-Guptill 1976) is a quarry of information and likely to become a standard work on the subject

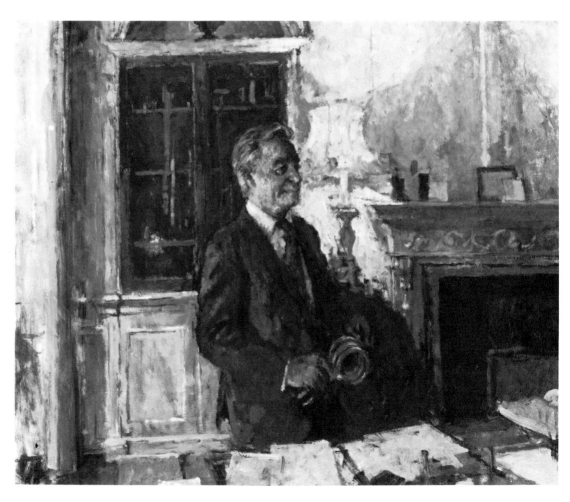

Lighting a sitter

A great many students of the portrait may not always be in the enviable position of being able to choose the lighting source for their sitter. Nevertheless they should know something of the subject and at what one should aim.

Single-source lighting

A study of the work of the master painters certainly shows one thing. With few exceptions, the light always appears to be coming from a single source. It may be high up, as in a Rembrandt, with the light casting deep shadows to the side of the nose and face, or low down as with Holbein and Gainsborough. But there seems to be unanimity that cross-lighting is to be avoided at all cost. One way of immediately telling the kind of lighting the painter was employing is to study the highlights in the eye, which should be literally reflecting the lights like a mirror. A really precise and meticulous painter like Dürer may even show the reflection in the eye of the window complete with mullions! Another way is to trace back the light source from the perspective of the cast shadows. It is for this latter reason that we are led to believe that Rembrandt must have worked in a high room. A typical Dutch window of the period was tall with a higher and lower shutter. If the lower shutter were kept closed this would certainly produce lighting effects very similar to those associated with Rembrandt. There is an interesting work on Vermeer in which the author has plotted the layout of the artist's windows based on the evidence of the highlights and cast shadows.

Cross-lighting

It is not accidental that there are few, if any, portraits with cross-lighting. The problems this produces for the painter are enormous. To begin with the colour temperature of the lights might be different in each case requiring a themal adjustment on either side of the face. It might also produce unnecessary complexity of shadow that would require much time and patience to analyse. This would not be a hardship if the end result were worthwhile. But cross-lighting also produces confusion of shadow in which the features are liable to become indistinguishable. A good portrait should be capable of being read as easily at 9 meters as at 90 centimetres (approximately 3 feet) and you can test this for yourself when you next visit a national collection. You will find that the better the painter the more the principle usually applies.

Lighting the features

The simple trick involved in the lighting of the face so that it carries satisfactorily at a distance is well exemplified in the works of Reynolds. Here the light is always arranged so that it accentuates the main features, arriving from the light source at around an angle of 40°. Thus there appears an accent of tone under each brow, the nose, the top lip and under the bottom lip. However far removed the specator is from the

portrait these accents will still remain visible as the eyes, nose and mouth, even if the resolution of their details is not possible.

Where this simple method of tonally accenting the features is not employed then the artist must rely on the massing of darks behind the head so that it is clearly separated, and again carries well. But the two methods are not mutually exclusive and should be used together. In the event of the sitter wearing a dark hat, or having a dark halo of hair, this will act as its own foil and a light background can be employed.

What we are really talking about is a system of tonal contrast that not only makes the form easier to read but which also provides variety for the eye. This variety is essential if the eye is to be engaged pleasurably and kept entertained. It is for this reason that in almost all the classical portraits, as you will see from many of those reproduced, the artist often employs a system of counter change. The dark side of the head will be set against the light and conversely. This method is used with telling effect throughout the picture and may be the reason why the English painters were so fond of landscape backgrounds. A sky may be darkened or lightened and remain acceptable to the eye without stretching credibility; a dark mass of green foliage can be introduced without explanation behind a red tunic or as a foil behind a peaches-and-cream complexion, a situation in which both tone and colour are complementary.

Lighting the background

While the lighting of the sitter is important one cannot afford to neglect what is happening elsewhere in the painting. Indeed the two are inseparably linked in terms of light and shade. It is a good idea to avoid at all costs an excessive literalism. Many changes of darks and lights may be safely introduced in the interest of the picture but without the suspension of belief. A much favoured device, for instance, was the casting of a shadow across the body, leaving the head and perhaps the hands still illuminated. This contrived to provide variety and at the same time suppressed the inessentials. There is never any indication as to what has cast such a shadow and any modern photographer who has sophisticated lighting equipment might be hard pressed to simulate such an effect. However, the eye accepts it all cheerfully, even admiringly. Nobody cares how or why the shadow got there and the painter's imagination, free from the dead hand of literalism, is completely vindicated.

Spot lighting

Much has been written about Rembrandt's familiar spot lighting technique but very little as to how we are beguiled into accepting illogicalities in the interests of picture making. For instance the self-portrait of him at the age of thirty-four in which the right side of the head is brilliantly lit should also have shown that the same quality of light was also hitting his shoulders and lower parts of the body. One is not even aware of a shadow deliberately introduced as in a Sully or a Thomas Lawrence. There is merely a lack of light. Logically it remains an impossibility but again it takes the eye away from lesser essentials and enables Rembrandt to concentrate on what he loved most, the play of light on the face.

Studio lighting

We have now arrived at three important considerations; (1) that light should be from a single source; (2) that counter change of light and dark should be introduced wherever possible and (3) that finally, literalism, or the exact rendering of what is there, should be avoided as being the path to dullness and banality. Of all these it is only the first that concerns our studio and lighting conditions and we can now examine how and what to do in order to make the best of these.

First, the word *studio* has always struck me as being slightly high-faluting as it merely means a place of study or work. French artists frequently use the word *atelier* which simply means a workshop. Eighteenth- and nineteenth-century painters referred to their place of work as 'painting rooms'. Estate agents and realtors often refer to a 'studio apartment', so the word studio clearly is supposed to have some kind of charisma. All the painter really requires is a room with one very tall window. If it is not very tall the light will begin to fall off after some 3 metres (approximately 10 feet) so that you can have a situation in which the light is stronger on the sitter's knees and feet than on the head. The studios of many successful Victorian and Edwardian portrait painters were purpose-built with the light source in mind and many of these are still extant, although they are not, unfortunately, always occupied by painters. These were also designed to have the large window facing north. When I was a student it was never explained to me why a north light was so essential to a painter and I assumed there was some mysterious quality it possessed that endowed all who painted in it with magical powers. The real explanation, alas, was far more mundane. A window from the north never receives direct sunlight. One shaft of sunlight in your room, and wherever it lands, the light and shade you may have so carefully arranged on your sitter are instantly destroyed.

Low-level lighting

A low window is almost equally good to paint by provided that you arrange the sitter fairly close in order to avoid the fall-off of light. The low-level light, such a window provides, will not produce the accents under the features I mentioned earlier. Nevertheless all Holbein's portraits appear to have been painted from a light with a low eye level.

It is normally best for the painter to sit with light falling onto his canvas from the left or from over his shoulder. This is simply because if he is right-handed he will not be in his own shadow. This seems to mean that the shadow on the sitter will normally fall on the right hand-side of the face and if you look through a volume of published work of almost any distinguished right-handed portrait painter you will find this to be the case. Incidentally, you will also find that there are a greater percentage of portraits that show the left-hand profile in preference to the right (George Dance, who drew almost everybody from 1780 to 1800, only drew left-handed profiles). This curious fact has nothing to do with lighting conditions but is explicable because it is easier for the right-handed artist to draw any line from top right to bottom left. Where light does fall short because the window is low this can be reinforced by a photographic spot light. This however leads to very hard edges to the shadows. One can

avoid this by constructing a box with four bulbs placed as though at the four corners of a square and covered with some diffusing material. Alternatively it is better to arrange two fluorescent tubes crossing at right angles as in the diagram. The Italian painters at the time of Leonardo approached the problem in a slightly different way and for different reasons. Florentines considered it bad taste to paint portraits with direct light and hard-cast shadows, and you will find no *quattrocento* portrait that has not the softest and gentlest of shadow gradations. The name *sfumato* was given to this effect and it is as though the volume is achieved without there being any direct light. Leonardo described how glass may be painted in gradated strips around the edges of the windows, thus avoiding the entry of any light that will produce a hard edge. He does not indicate what kind of paint he used on the glass but oil paint thinned down with turps using ivory black, which is transparent, would no doubt have met the situation.

Surrounding colour

Clearly, the colour of the walls in your painting room will exert some influence on shadows on the sitter's face by way of reflected light. If you have set aside a painting room and you wish to know what colour to paint its walls you might like to bear in mind the following considerations. First avoid hot colours. As you will see from the chapter on colour balance it is normal and indeed characteristic for flesh to turn cool in half tone. A hot reflected colour would destroy this typical optical effect and you might be left with a dullish monochrome to your flesh. Cool surroundings are therefore preferable but a brilliant white may produce obstrucive reflections. One is therefore left with a low-key cool colour as the best possibility, perhaps a warm grey, with the coolness predominating. Ceilings should always be capable of some reflection. I once painted a portrait of a brunette in a converted barn in France. The Provençal light from the window was fine. But the roof had pine boarding stained almost black and the result was the top of the hair appeared so black as to be completely formless due to lack of reflected light.

Extra light

Throughout this chapter I have considered lighting solely from the point of view of the professional portrait and its requirements and not from the point of view of making highly interesting and imaginative studies which might plunge the head into heavy shadow in which the likeness might be lost. In general it is always best to work in tried and known conditions of lighting. That way the result is likely to be more predictable. The sad and no doubt unfortunate aspect for the professional portraitist is that everybody is inclined to want a portrait along the lines of the work they have already seen him or her produce. Any radical departure from the lighting conditions and backgrounds already seen in your portraits and the client may feel cheated. It is therefore best to introduce innovations in portraits painted for your own pleasure, unless you have made whatever innovation you propose clear from the outset.

Artificial light

A word should be said about artificial light. Normal light is tungsten which, in terms of the spectrum, is of an orange cast although it may not appear so. Paintings carried out under it will naturally change your appreciation of colour and although after long experience it might be possible to anticipate the thermal adjustment required in your colour mixing, it is simpler to fit up your painting room with a colour matching fluorescent tube, or tubes. It is essential that they are designed to reproduce daylight. Osram make a tube whose specification is that it reproduces daylight as it is over Washington DC on 21 June at 12 noon, a scientific attempt to standardise daylight at which most artists are likely to boggle. I know Washington and I wonder whether this specification has since been up-dated to include the daily announced air pollution index which must certainly affect the quality of light-whether on 21 June or any other day. In theory polluted air should make daylight warmer due to increased turbidity.

Hugh Gaitskell Richard Hamilton
Arts Council of Great Britain
In the chapter on the role of the portrait painter I wrote that a truly critical portrait was rare. Here then is a rarity. It was produced when Hugh Gaitskell was leader of the Labour Party and from anger at his policies. Much of the work has been produced through the agency of an enlarged half-tone press photograph. The major paint contribution is the bloated red-veined eye. However it remains more in the tradition of caricature than portraiture

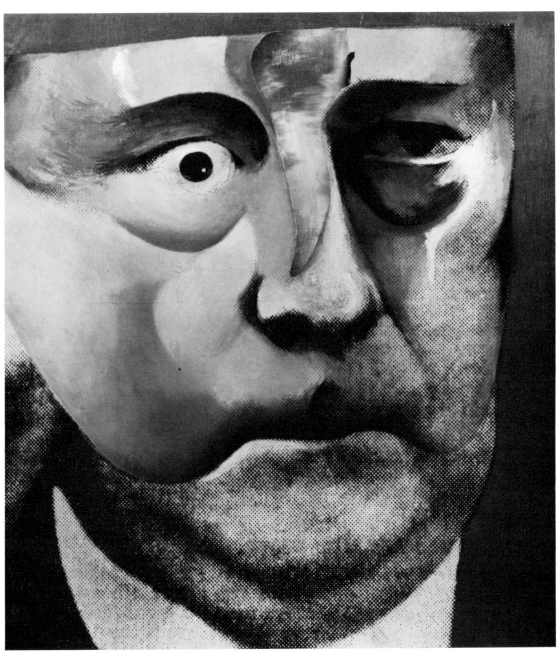

Problems of the likeness

Make the sitter as distinguished as possible, a painter once said, and they will find the likeness. I am not sure whether this meant as a reflection on the painter or on human frailty. Another version on this theme is the observation that it is a truthful portrait but beautifully told. Both of these remarks suggest that in a painting people expect to be well thought of. Indeed many portraits are commissioned by independent bodies such as Companies, Institutions and Universities precisely because the sitter *is* well thought of. We are not only touching therefore on the resemblance but on matters of a human's contribution to society, to his respected and positive qualities and perhaps, in the end, to the dignity and worth of the individual.

What Desmond McCarthy has written of biographies applies equally well to the portrait. He wrote, 'Biographies are artists on oath. You must ask yourself with every fact: does this trivialise or does it bear on this man's achievement?'

It is however one thing to recognise this and quite another to be able to transfer one's exact conception of the person to canvas. I find that a portrait seldom works out precisely as I intended or planned it. Accidents play a part. So, as we have seen earlier, do unconscious comments. The safest procedure is always to try to be as objective as possible, whilst at the same time studying those artists greater than oneself whose portraits are not only likenesses but provide rich human experiences.

Objectivity means being able to draw with consummate accuracy, but this does not mean being dull or stilted. The major part of drawing is to be able to measure angles of lines in space as well as proportions, and to imitate them on your canvas. However, this book assumes some proficiency in the student who must already know that of all the drawing arts, portraiture is the most difficult.

I do not know which of the features is the most important in establishing the likeness. I only know which by general agreement is the most difficult. Gilbert Stuart, the painter of the famous portrait of George Washington, thought the nose the most important feature in giving the likeness to a portrait and even recommended to the painter that he draw that side of the face that presented its handsomest outline.* The popular view with which all portrait painters are familiar is that the eyes are the key to the whole business and unlock not only the doors and windows of the soul but also are the most difficult to paint of all the features.

Interesting as the eyes are by general accord, it is the mouth that is not only the most important feature in forming the resemblance, it is also the most difficult to paint. John Singer Sargent wrote, 'A portrait is a painting with something wrong with the mouth'. Some phrases have the ring of truth; others hit you like an explosion. It would be true to say my

* The remark attributed to Gainsborough 'Damn the nose... there is no end to it?' referred to Mrs Siddons about whom Gainsborough seems to have taken Gilbert Stuart's advice.

attitude to painting the face has been crystallised for all time by this remorseless but deadly accurate comment; all battered professionals will bow both to its wit and sense of *dèja vu*, or, if you wish, *dèja* felt.

The mouth

The mouth unquestionably establishes the mood of the painter as well as the likeness. The mouth also happens to be the most mobile feature of the face since it is able to move three-dimensionally as well as through 180 degrees. The eyes are a well of repose by comparison. In a sense, therefore, the painter is trying to fix a moving object; by the very act of fixing it the likeness can be changed since nobody perhaps has seen it stilled. I once painted a lady who was a fairly close friend. She was lively and extrovert. But as soon as she sat still and her mouth was in repose I realised for the first time, and with a mounting sense of dismay, that she had protruding teeth. Who would recognise her with protruding teeth? Perhaps not even her husband!

There is no ready formula or set solution to the problem. The fact that Sargent, who painted with such brilliant virtuosity that half-open moist mouth in the portrait of Vernon Lee in the Tate Gallery, should consider the mouth such a problem, is perhaps not the most encouraging of thoughts to the budding portrait painter.

The first practical problem with the sitter's likeness is undoubtedly to achieve repose in the mouth and then to study with the greatest care the line formed by the meeting of the lips. This line is to be seen at its most typical in a Greek cast with its Cupid bow effect. All mouths in one form or another conform to this mould although it is often very difficult to distinguish. For example some mouths can literally look as though they consist entirely of a straight line. Nevertheless, somewhere the discerning eye will be able to detect this typical cupid bow formation and its needs to be slightly emphasised. One meets an overwhelming difficulty with the mouth that is normally half-open and therefore is such a distinguishing characteristic of the person that it cannot be rendered in any other way. This requires the most careful observation combined with the most felicitous of touches, the kind of effortless ease to be seen in Gainsborough's painting of his nephew, Dupont, whose pursed mouth seems flicked in with no more than three unerring strokes. Beware, incidentally, of making the mouth too dark between the lips. It is seldom as dark as it appears. And mouths do not end suddenly as though they were a gash; each corner forms a small hollow. These hollows which normally lie at an angle of approximately 45 degrees at the corner of the mouth are very vital both to the mood and the likeness. There is always a tendency to make these too severe by over-estimating the tone or drawing them at the wrong angle. There are enough severe people in the world but their percentage seems to increase on the walls of portrait exhibitions. And this is why its rendering is so crucial. The matter is neatly summed up by the observation of a mature student, who discussing the problem, said to me, 'I always know the mood my husband is in, when he comes home, by his mouth'. It was the remark of a portrait painter in the making!

42

The eyes

Let us now take that old cliché about the eyes being windows of the soul. If the mouth establishes the mood, the eyes certainly help to hint at the personality and to that extent they contain a longer-term view. Experiments have shown that the eyes are the first part of the face that we normally look at, and the mythology around them may not be entirely based on them as organs of vision or as emotive parts of the face. Experiments by two Soviet biologists on the mysterious and as yet unquantified energy which enables certain individuals to move objects without touching them, have shown that it appears to emanate most strongly from the eyes,* so it may well be that the power, force or attraction of the eyes may prove to have a scientific basis. Although this information is interesting to the portrait painter he must first be aware of the eyes as tonal accents, normally the darkest of the face. From the likeness point of view he must establish correctly whether the eyes slope upwards or downwards, how deep-set they are and how much of the upper lid is showing, among a great many other sophisticated details. From my experience of student paintings, there is also a tendency to make the brow too thin, like a relic from the Clara Bow period. The anatomy of the eye is also often misunderstood. The eye is a ball with the iris forming a slight projection like a boss. When the eye is turned, the iris therefore tends to stretch the lid and change its ellipse and this has to be carefully watched for. Another common error is to produce too much of the white of the eye and not to notice precisely how much of the iris is occluded by the top lid. This has a great bearing on the likeness. With most normal people about a third of their iris is cut off at the top by the upper lid; but in some cases, such as young babies and people who are exothalmic, the total iris is visible.

The effect of not making the iris the exact size has an interesting effect on the likeness. If it is made too large the face is made babyish; if too small the face takes on a mean look. Unfortunately it requires great experience to determine such slight measurements. The iris itself is ringed with a darker pigmentation with the pupil in the middle. The pupil is not a colour but a dark shadow, literally a hole allowing light into the eye. It should not therefore be treated as local colour but as a shadow. It must be placed with great care, including the iris; for of all the areas of the face where the slightest deviation in drawing is critical it is the eyes. The mouth may be rendered out of drawing and remain a normal mouth; two eyes out of drawing produce an opthalmic abnormality.

If you feel you have lost the likeness of the eyes, check with great care their angle or slope from one corner to the other. This can be literally measured from the horizontal with a protractor. To do this well it is necessary to train your eye to concentrate minutely on the area. Another area to check carefully, and where the likeness can go wrong, is the distance of the tear duct corner of the eye from the nose. I have noticed a tendency with beginners to place this too near; sometimes this might be over-compensated by extending the eye and making it too long.

* Quoted in *Super Nature* by Dr Lyall Watson.

43

The nose

There are two common problems with the nose. The first is what I call 'the small outer nostril syndrome'. Almost unfailingly and inexplicably the wing of the nostril is made too petite; where it should be made to extend something like one third up the nose it is made instead to to occupy only one fifth or sixth of this area. Even experienced painters and draughtsmen often misjudge this. The next problem is that of foreshortening the nose. When the nose is facing you and the light is coming from above, clearly, the tip of the nose to the top lip will be in shadow. However this is a less common problem than drawing correctly the elliptical form of the nostrils although from this particular angle they appear more as lines, with perhaps a slight change of direction towards the tip of the nose. The angle of these lines is again critical to the likeness. I appreciate that what I have been dealing with are more drawing than painting problems. But in the portrait the two are indistinguishable. Painting is after all another form of drawing. (The word *pencil* has changed its meaning since the eighteenth and early nineteenth centuries when it meant a brush.) The one way of checking your drawing, and the way which has become the butt of many cartoonists, is to extend your arm full-length and use your thumb to measure the point on your brush or pencil and using the end as the other point. This can work satisfactorily when big areas are involved but in my view is not refined enough a method for something requiring such exactness as a portrait. I therefore, in addition to concentrating with great care on the direction and angles of individual parts, employ the following method which I believe to be superior to any other. Look at your sitter and back at your painting in rapid succession, say six times in six seconds. When this is done rapidly enough the image of your sitter will be almost projected over the painted or drawn one as though it were on tracing paper. Where your drawing is inaccurate the after-image will indicate this by making it twitch slightly (or enormously, according to how much out your drawing happens to be!). Although I now draw instinctively to some extent, that is without consciously measuring, this is a mandatory method when I am in doubt or difficulty, and you may find your own drawing will improve enormously by adopting it.

Ways of correcting the likeness

It is a well known device employed by painters when they are in doubt about likeness or proportion to look at their painting in the mirror. This sudden reversal of view can often reveal an obvious error to which they have become blinded through over-exposure, in the same way that many people fail to be aware of blistered paintwork or a worn carpet because they may have been there for so long. A further trick which I employ myself, although this can be applied generally and not just to questions affecting the likeness, is to turn your back on the canvas. Then turn quickly so that you get no more than a fleeting glance at your portrait and return to your original position. The effect is rather like subliminal advertising! The impact of the portrait is so quick that the eye is forced to take in only its essential features; precisely because there is no time to

dwell on the details you are forced to make a quick decision as to whether the general effect is right.

If neither of these methods helps to provide you with your likeness then the only way is to return to a careful and painstaking analysis of your drawing. I would suggest you check on the following aspects. One of the most important is the angle formed by the outside point of the eyes and the nostrils. This will decide whether your eyes are set too close together or too far apart. The length of the top lip must be carefully measured; again it is little use, in my experience, in making such a fine measurement except by looking repeatedly backwards and forwards from your sitter to the drawing. A further crucial aspect of the likeness may be determined by the angle of the lower jaw. This will affect the squareness or otherwise of the face. However, by this time the reader no doubt will have realised that almost everything, unless accurately observed, seems to affect the likeness. One might say that was the bad news. The good news is that I recall trying to draw my very first portrait as a student and thinking that the achievement of a likeness was not humanly possible, for no eye could possibly be attuned to the measurements of millimetres.

Overleaf
William Ewart Gladstone Sir John Everett Millais (1829–96)
National Portrait Gallery, London

Gladstone Rupert Potter (page 47)
Christ Church, Oxford

While we know that Millais used no photographic help for his earlier portraiture, he is known later in life to have frequently used the services of Rupert Potter, the photographer brother of Beatrix. It was Rupert Potter who took the photograph of Gladstone shown here and whose closeness to Millais' painting is much in evidence. However, although the pose is almost identical, as well as the eye level, all the changes in the folds of the gown indicate that Millais used it merely as an *aide memoire*, and perhaps solely for the likeness. There are infinitely minute changes in the likeness of which the most apparent in the painting is the shortening of the length of the upper lip and a narrowing of the width of the mouth. But these were probably not matters of which Millais was conscious; nevertheless the cumulative effect of a series of *tiny* errors in a portrait may produce in an inexperienced painter a complete impasse of effort in which every feature looks right in isolation yet nothing looks right together

45

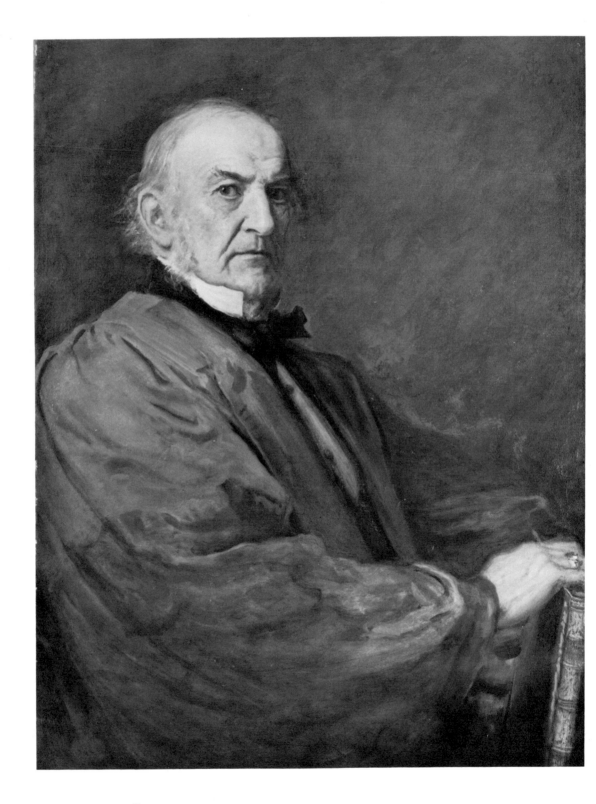

47

Sir Joshua Reynolds' Camera Obscura
This interesting optical instrument, disguised as a book was presented to
the Science Museum, London, in 1875 and can be traced directly to Sir
Joshua's ownership. I have set it up and, despite the poor condition of the
lenses, it projected a satisfactory image. However, it would have been
impossible to have placed a canvas larger than 60 cm (24 in.) in width in
its interior and for practical everyday use it would be very cumbersome.
It is just possible that Reynolds traced head drawings from the projection
and these were later transferred on to canvas. For any competent
draughtsman it would be quicker to draw directly on the canvas from life

Portrait painting and photography

There is an engraving by Dürer which shows an assistant looking through a lense at his sitter. Between the sitter and the lense is a squared-up screen. By transferring what is seen in each square to a previously squared-up paper one arrives at an aided system of accurately drawing a portrait.

Aids to help artists to draw are not new and it would be unrealistic in a book on portrait painting to ignore them. Photography is certainly such an aid and is used by many portrait painters in varying degrees, some almost totally, others in special circumstances.

Camera obscura

It is right, however, that the relationship between the artist and the camera should be seen in its proper historical perspective. The camera really developed from the *camera obscura* which was first described at the time of Leonardo. It consisted of a darkened box with a lense at the top. By removing one side of the box and substituting a black curtain a spectator could insert his head and watch the projection of the surroundings on a piece of paper. This image could then be traced. Canaletto is said to have employed such a device and it has been argued, in my view unconvincingly, that Vermeer also used one. Opposite you will find reproduced the *camera obscura* that belonged to Sir Joshua Reynolds and which I have examined and used in the South Kensington Science Museum. Its one puzzling feature is that it is disguised as a book which may possibly have meant that Reynolds entertained the same ambivalent feelings towards it that artists were to have later to the camera.

Camera obscura
The Science Museum, London
Below Unopened position as a leather bound volume
Opposite Fully opened, the volume forming part of the base

49

Camera lucida

The *camera lucida* was another optical forerunner of the camera and this enabled a portrait draughtsman to trace a profile on paper by looking with one eye through a prism on a support, which when correctly angled, floated the portrait image on the paper. This optical novelty still sometimes appears as a children's toy but nevertheless seems to have been used seriously by some artists, such as Cornelius Varley, in England in the early nineteenth century.

Graphic telescope

An intriguing variation of the camera lucida was devised by the artist Cornelius Varley (brother of John) who had sufficient belief in its usefulness to protect it with a patent in 1811. The Science Museum, London, possesses the original model used by Varley himself and which is reproduced below. It could be compressed into a mere 12 cm (5 in.) in length and was thus highly portable and also gave much better results than the camera lucida. To what extent this gadget was used by Varley and other artists is not known. My own discovery of it was accidental, while exploring Reynold's camera obscura, but the instrument is well known to the optics department of the museum. It functioned horizontally, one eye looking through the small aperture on the left, and leaving the other eye to concentrate on the paper below. When focused the image was then seen to float onto the paper and was easily traceable. The instrument had a magnification of nearly three diameters, ample enough to copy a head life size. It is curious that this very practical instrument seems to have sunk without trace for it can be used equally well for landscape and topographical drawings.

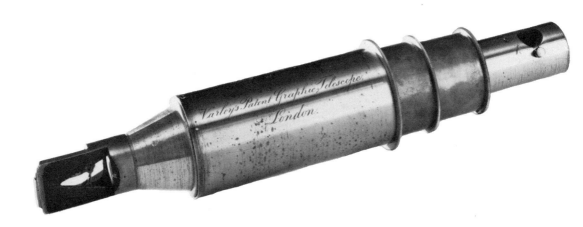

Graphic telescope
The Science Museum, London

Dr Spurzeheim Cornelius Varley (1781–1873)
The Science Museum, London
Drawn by Varley himself with the aid of his patented graphic telescope.
Even allowing for the poor quality of the print (the drawing was
photographed *in situ* in the Science Museum for it was impossible to
remove it from its case) it is not a good drawing and Varley might well
have done better without the use of his ingenious gadget. Nevertheless Sir
J Herschel's drawing of a Greek temple, drawn with the camera lucida,
is remarkably good, so clearly neither performance is a reflection on the
instrument

Daguerrotype
The next logical development of both these instruments was the fixing of the projected image on a flat surface and this finally happened in 1833 with the discovery of the daguerrotype. The impact this discovery had on the world of art and artists has now been well documented. Not only do we know that almost every important nineteenth-century painter, from Ingres and Delacroix to the Impressionists, made use of it but also that the early photographers were nearly always painters. Painters *manqué* perhaps, but as painters they were trained. It was because of the efforts of one of the leading French painters of the day, the history painter Delaroche, that Daguerre's achievement was recognized by the French Government. Painters were not grudging of the invention. On the contrary it was welcomed by nearly all of them despite the potential threat some saw it representing, a threat that was strongest to the portrait painters. The daguerrotype with its finely chiselled modelling was the poor man's Ingres. It even looked like a miniature Ingres.

Artists' views
What was the good, artists were later to argue and particularly those of the abstract school, of painting a portrait in the style of realism when the camera could do it with greater ease? 'In what', wrote Sickert, 'does the painting by Ingres differ from a plate of colour photography? First in this, that all dross, external to what has interested the painter, has been fired out. Then each line and each volume has been subtly and unconsciously extended here and contracted there, as the narrator has been swayed by his passion, his rhetoric'. In explaining this Sickert was also explaining the nature of art. If a photograph is slavishly copied by a portrait painter he is removing all comment and interpretation of his own, and in the end is effacing what is most valuable in any painting, his own personality. The following story shows how and why one artist used photography. Shortly after I left art school one of my first jobs was the preparatory drawing of a portrait on canvas for David Jagger. This was to be a copy of his portrait of a refugee which had attracted attention at the annual Royal Academy exhibition. Jagger worked on a monochrome under-painting carried out in almost any medium from conté to lean paint. This monochrome was normally executed entirely from a photograph. His explanation was that by using this procedure he had few, if any, failures, whereas working from life he had had occasional rejects. Although the art world did not rate Jagger's work very highly he was an accomplished craftsman, and sitters almost queued at his studio door.

Practical use
Following the monochrome stage, Jagger then had a sitting from life. But he still relied heavily on the photograph. To this end he had his photographer produce three prints. One was normally printed, another under-printed and the third, over-printed. The print that was under-exposed (or printed) showed shadow detail which would be unavailable with a normal print. The third, and darkest version, showed very clearly the highlights and their exact shapes. This enormously facilitated his vision but it seemed to me at the time to turn Jagger into a highly efficient

painting machine and little else. However, it would be a mistake to believe that it reduced his observation, for he pointed out to me the bloom on one of his female sitter's cheeks visible only at its edge, and produced by a soft down of hair which he claimed all women possessed. This he painted in his portrait but it was certainly invisible in his photograph!

A successful portrait to Jagger in artistic terms seemed geared entirely to its likeness and precision and therefore his portraits were never surprising, or venturesome, but always safe; and indeed this is no doubt the *cul-de-sac* in which the employment of a method so dependent on the camera must inevitably lead. However, Jagger was wary and wise enough to know that the photograph even when perfectly exposed does not give you the whole truth, apart from its purely monocular view, because shadow and highlight detail is often lost. Hence his use of the three graduated exposures. The squaring up of a photograph and its transference to a squared canvas is a procedure used by many portrait painters and was a method employed by Sir Gerald Kelly, PRA. In his hands, however, such a method seldom produced unsatisfactory results.

Photography and substitutes for nature

It seems to me that a highly imaginative and successful portrait (and likeness) can be produced from a photograph in conjunction with sittings, as well as a dull and poor one. Photography is a substitute for nature and everything in the end will depend on the artist and what he is trying to express. The greatest writer on art matters in the English language, John Ruskin, urged his students to copy from a small and simple photograph. To him, as to Delacroix, who drew many nudes from photographs, photography provided a variation from the copy of engravings. However, portrait painting must be seen as something set slightly apart from painting as a whole in that its record aspect, like that of topographical art, tends, not unreasonably, to dominate the painter's thinking.

Photography has helped the client to be far more demanding. Hubert Herkomer, a notable Victorian painter, used photography as an aid to his portraits. He wrote that the universal use of the camera had conditioned the modern public to a more critical estimate of the likeness. 'Photography has therefore, trained the public in "likeness seeing", with the result that the portrait painter has to meet much more exacting criticisms in matters of likeness than the painters of earlier days'. This is certainly true and any high-minded aesthetic view that does not take this into account is bound to appear out of touch with reality to a practising professional painter.

A different view was taken by Whistler although it should be noted he does not necessarily resile from its practical use. He records, 'The imitator is a poor kind of creature. If the man who paints only the tree, or flower, or other surface he sees before him were an artist, the king of artists would be a photographer. It is for the artist, to do something beyond this: in portrait painting to put on canvas something more than the face the model wears for that one day; to paint the man, in short, as well as his features'. All portrait painters are familiar with the day-to-day change in a sitter's appearance, as well as the paradoxical phenomenon that photographs are not always like the sitter, especially those that appear in

a passport. However, Whistler painted portraits but was not primarily a portrait painter. Indeed he called his portraits 'symphonies and arrangements' and even the painting of Carlyle is also named 'Arrangement in Grey and Black No. 2' so it seems he was never over-concerned with their impact on their recipients.

The painter's dilemma

The dilemma of the portrait painter with regard to photography may be summarised thus: if he relies completely on photography to produce his likeness he may better satisfy his client but might not please his peers, who are not looking for excessive naturalism. But if he pleases his peers by a freer interpretation he may lose his client. However, nobody who can draw well requires to copy from a photograph and if he cannot draw no photograph will help him anyway. If one accepts the premise that the camera is an aid to achieve the artist's end, but is not an end in itself, there is surely little problem. The camera, like a sketch book, can be a useful purveyor of information, but in my view nothing more; the quality of the reality a photograph supplies is a fourth rate deputy of the real thing. Nevertheless, one may have to rely on it for 'difficult' sitters, among whom are young children and animals. Even here it is better to use the camera only for the underpainting stage. My late labrador, Sophie, seen in the painting with my daughter, was underpainted with the use of the camera. However the *alla prima* stage was completed by holding her collar with my left hand and fixing her head in the correct position and painting her with my right hand. This proved less difficult than I had anticipated since she proved both a docile and good-tempered subject.
A further dog that I portrayed, I painted from life. But the hazards were unexpected. To keep the dog looking up my sitter had to feed him constantly with biscuits. The dog slobbered incessantly; so much was going over my sitter's delightful black velvet dress that I had to call a halt before she floated out on a wave of saliva. Fortunately by then I had captured most of the dog's pose.

A unique aid

Finally, the following unusual story concerns the use of stereoscopic photography in a portrait by the English painter John Walton. Painting groups as he often does in the Scottish Highlands, he became dissatisfied with his ability to distinguish a range of low mountains in the distance and which he required in the background of one of his portraits. He took one photograph from where he was painting the range, then travelled some 400 metres parallel to the mountains and took a further photograph aimed at the same point. The film was processed and the artist was able to identify with ease the relative positions of the mountains in a three-dimensional setting by using a stereoscopic viewer. Such a wide angle increases the effect of stereoscopy. Not many portrait painters would have hit on this particular solution, which is typical of John Walton's painstaking approach to his work. It would also be difficult to find a more interesting example of the camera used as a legitimate and unique aid.

Caption overleaf

Claude W Chadburn John Walton (page 55)

John Walton is undoubtedly one of our finest craftsmen. Although it may not be apparent from this reproduction he is also technically inventive, having evolved for himself a system of painting that suits his particular needs and consisting of small cross hatch strokes made with a sable brush. In the early underpainting stages he uses no oil (which he considers to be the enemy of pictures) and uses his little finger as well as brushes, freely to apply the paint. Only in the final stages is oil introduced and this is normally a sun-thickened quick-drying variety. His portraits are extremely sensitive to small colour and temperature changes. He works slowly and painstakingly and in his own words 'has the patience of a cat'. This portrait shows his ability to view objectively the sitter's environment and the personal possessions that have played a part in his life

Mussorgsky Ilya Repin See colour plate facing page 72

Tretyakov State Gallery, Moscow

Repin occupied in pre- and post-revolutionary Russia a position in the fine arts as important as that of Tolstoi in literature, yet this work remains relatively unknown in the West. He was a draughtsman of extraordinary gifts comparable in stature with Degas although the major influence on his work stems more from the German artist Menzel. This painting of the ailing composer has a sense of extraordinary actuality, and the dishevelled hair and beard and the rheumy eyes are viewed uncompromisingly and without any of the gloss of say, Ingres' portrait of Count Guriev. Within a few weeks of the completion of the portrait Mussorgsky was dead from alcoholism

The Painter's Daughter with Sophie Detail

See colour plate facing page 73

Once commenced this portrait was worked on almost continuously until completed. The figure was carefully underpainted first to establish the likeness and, more important from the viewpoint of its pictorial qualities, the disposition of lights and darks. These were carefully arranged so as to produce the maximum tonal variety. Too often students become fascinated with glazing, the superimposing of transparent layers of colour in a varnish medium, at the expense of direct painting for which there is no substitute. However glazing is often useful in obtaining the maximum luminosity of colour from reflection through the ground. The shadow under the hat was obtained by glazing ultramarine over the dark raw umber underpainting which partly filters through modifying its brightness but increasing its luminosity. The background is an imaginary classical pastiche

Miranda Derek Chittock

Painted in a room that had a high window, seventeenth-century Dutch style, where I was intrigued by the deep shadows. However the lighting was so critical that the slightest movement of the head produced great variations in the light and shade, particularly from the brim of the hat which trembled like birch leaves in a breeze. I underpainted with raw umber diluted solely with turps and painted on it the following day, using a palette of ivory black, flake white, yellow ochre, light red, and as a concession to the faint floral pattern on the dress, alizarin crimson. A portrait painter's dictum might well be 'expect the worst, but hope for the best'. Miranda's right eye was painted largely from memory. In the middle of painting the portrait she dived in a river, split her brow and the white of the eye became a rich crimson

Lord Rockingham and Edmund Burke *Sir Joshua Reynolds* (1723–92)
Fitzwilliam Museum, Cambridge
This unfinished canvas demonstrates Reynolds' practice of covering the whole canvas before attending to the head, an excellent procedure which is discussed elsewhere in the book. The faces of both are underpainted in black, lead white and red which seems to have been Reynolds normal practice. Some of Reynolds' heads have become extremely grey, almost cadaverous looking, for with the passage of time the overpainting in a fugitive lake has faded and allowed the grey an over-prominence. Reynolds only tinted the under-painting after it had dried, using a glazing technique. This could easily be removed by an enthusiastic nineteenth-century restorer and could also account for the mono-chromatic greyness of his flesh colour in certain portraits. It is not clear why the portraits were never completed and there is documentation that Rockingham and Burke had only three sittings each between January and December 1766

Drawing, preparation and underpainting

Portrait painting differs from most other painting activities in demanding the most exacting and painstaking attention to the drawing, for without this the likeness can be lost and with it all claim for it to be a reasonable record of the sitter's face. Some art schools have taught students to believe that the likeness of the sitter is not important, claiming instead that the qualities of the painting are what matter most. However there is no conflict between a painting being a record as well as a work of art. History abounds in examples. So that to ignore the more functional aspect of the matter, indeed its whole *raison d'etre*, is rather like asking a carpenter to make you a beautiful table only to find that its beauty is undermined because it only has two legs.

Because of this functional aspect of the portrait it has been customary for its preparation to be fairly elaborate so that little is left to chance. For this reason underpainting in monochrome first was frequently a standard practice from the Florentines onwards, although, as you will see in some of the examples in this book, not all masters were absolutely consistent in employing this method. However, in my view, inexperienced painters can only abandon some kind of careful underpainting at their peril. Master draughtsmen can be left safely to see that their brush strokes arrive first time in the right place and with no lack of decision. Lesser mortals are left to conceal their blood, sweat and toil with an underpainting so that their drawing, and, to some extent, tonal problems are sorted out first. Because this underpainting will eventually almost disappear, it matters little how often it is changed or muddled over, provided that in the end the likeness, proportion, disposition of lights and darks and general feasibility, have been established. In other words, underpainting is based on a division of labour in which the drawing and tonal problems are partly solved first, and colour and its allied difficulties dealt with at the second stage.

There are few modern painters that practice underpainting, perhaps because it is time-consuming and partly because modern abstract work does not require it; neither does the latter require the high standards of technical skill that is to be seen in classical painting. There are however many reasons, even apart from portraiture, why it is a fine procedure, even if not to everyone's taste. As oil paint ages it also becomes transparent and allows the ground to appear. As it also yellows, the appearance of a correcting tonal influence underneath becomes increasingly prominent and thus one fault is allowed to correct another. These advantages however are more incidental and it is certainly better for the student to look at it purely from a practical point of view, namely that the underpainting is a kind of dress rehearsal which allows you to see how everything might look on the night including its shape, pose and composition, without however being too committed to the final outcome.

The imprimatura

There are few painters, and the portraitist is no exception, that are happy painting on an entirely white ground that has not been first rubbed over with a transparent veil of raw or burnt umber, ivory black, or terra verte. Practice has varied from the Renaissance onwards as to how dark this has been or whether it was cool or warm. It is usually called an *imprimatura* and the only thing that can be said for certain is that it should always be transparent. This way the underlying white ground is allowed to achieve the maximum light reflection through the paint layers. It is true that I have examined many unfinished paintings of the seventeenth and eighteenth centuries in which the toned ground appears to be opaque, but these will certainly, as a result, have dropped in tone. I once painted two portraits almost at the same time, one of which was over an opaque grey ground and the other over a transparently tinted ground. I was surprised to see that the former dropped noticeably in tone within a few days and I therefore never repeated the practice. However, much depends on the thickness of your *alla prima* layer; naturally the more opaque this is, the less likely is there to be any lowering of tone.

The *imprimatura* should be thinned only with turps (not oil) and if you are undecided as to which of the tints to employ you should allow experiment to produce an answer. In my own practice I employ raw umber with a tone no darker than sandpaper. Rubens favoured, however, a grey (and slightly streaky) tone; the Italians and many English painters favoured warm and sometimes quite dark grounds. However, there are a number of unfinished works on white grounds. Sometimes these have turned grey with both age and dirt and it is not always possible to distinguish whether the tint is there from time or intention. Interestingly I never come across a blue *imprimatura* and I think there are a number of good optical reasons why this is so. These are certainly connected with the fairly consistent use of brown for underpainting in all shadow areas and we can now examine why this colour seems to have been always so favoured. To understand this it is necessary to jump a little to the chapter ahead on colour mixing. It is a principle that all colours are subdued and their brightness lessened as they turn into shadow and this can be normally accomplished by the addition of the complementary colour. This procedure means that a green becomes warmed (by the addition of red) and that red colder (by the addition of green). Even blue, the coldest colour, becomes warmer in shadow by dint of decreasing its intensity with orange. Thus we see that while hot colours do not entirely lose their hotness (otherwise their hue would also be lost) cool colours are always made warmer. Thus the total effect of local colour in deep shadow is of warmth whatever its hue. There is only one deep colour that foots the bill and that is brown (made incidentally by mixing the three primaries together where the warm colours outnumber the cold by two to one). In my view these are the optical reasons why brown has predominated as the underpainting colour, whether it was Cassels brown, Van Dyck brown, burnt or raw umber. I do not think that the master painters had a satisfactory scientific explanation as to why they used brown; perhaps it had built up on a purely trial and error basis as being pragmatically better. Culminating with Rubens, the common practice was to allow the

underpainting in the shadow areas to appear unadjusted or slightly glazed.

Underpainting

Let us then now proceed with the underpainting in say, raw umber (which is not strictly brown but has a slight greenish cast). We have produced a brownish monochrome which is correct in most particulars to our portrait as we wish it to appear were it to be without colour. It is advised by some authorities (eg Max Doerner) that the pitch of the darkest tone should never be quite as dark as it appears in order to allow for the later overlaying of the local colour which will inevitably lower it in key to the required amount. Like all refined arguments one is inclined to read about, they tend to become academic in practice. Practice is not only always the prime mover; it is also the prime teacher. Perhaps in the beginning was the deed and not the word. So whether you are making your underpainting too light or too dark, only experience will tell. For what it is worth, however, my experience of students and amateur painters suggests that modelling of form tends to be too shallow, which means the darks are usually not dark enough.

Reynolds underpainted his heads in black, white and red, although not consistently. This may be the reason why some of his portraits have developed a ghostly pallor by dint of the increased transparency of the paint. Green, such as terra verte, is used for underpainting. But in classical practice this was favoured for modelling and blocking in the flesh areas. The National Gallery, London, has an interesting unfinished Michaelangelo in which certain parts of the limbs have been left green, while the Virgin's robe is underpainted in black, ready to receive some glazing treatment. Green in this instance provides a cooling influence on flesh tints as it is the complementary colour of the pink in flesh. Many contemporary portrait painters employ a green or raw umber ground and this is allowed to show through the flesh sometimes in uncovered areas and sometimes through flesh tints applied semi-opaquely. If you are experienced enough, a darkish umber or grey ground will produce tonal gradations even though you may have mixed only one flesh tint on your palette. By allowing the dark to filter slightly through you will have one tone; mixing the same tint more stiffly will produce a lighter one. The effect is no different from drawing with chalk on a blackboard. Draw lightly and the chalk is semi-opaque and not very light. Draw more heavily and it becomes lighter.

From the evidence of many pictures showing eighteenth- and nineteenth-century painters at work it can be seen that when working on a dark ground, many artists first sketched in the forms with white chalk. There appear to be traces of white chalk on the lower right hand corner of Gainsborough's unfinished painting of his two children (page 65). Hogarth also portrayed artists working in this way. But it is likely that this was merely a preliminary to placing in the outlines with an umber tone. There are unfortunately far too few manuals on the practice of earlier painters of any stature. Perhaps they were too busy painting to write. Some may have been too secretive about their methods to wish to divulge

The Painter's Daughters Thomas Gainsborough (1727–88)

National Gallery, London

Painted directly on a warm half-toned ground with only scanty preparatory drawing. The arm and sleeve on the right, for example, have little or no containing line and have been directly indicated in colour. There are some indications of chalk lines on the lower right-hand corner although these will not be visible in reproduction. To the right of the taller daughter's ear are the telltale marks of Gainsborough's mahl stick on which he rested his hand when painting. This is positive proof that background and heads were painted simultaneously. Although charmingly incomplete there is not one area that could not be advanced with ease had Gainsborough so chosen. The flesh tints are pink and silvery, an unmistakeable tribute to the influence of Van Dyck

them to rivals. Reynolds, for instance, kept a technical notebook, but written in Italian. The lectures delivered by the earlier Academicians are not generally concerned with the practicalities of painting but more with its lofty aims. For the practice of the Italian, Flemish and Dutch portrait painters we are for the most part entirely reliant on scraps gleaned from letters, a few eye witness accounts, and pieces of gossip. However, in *Hints to Young Painters*, we do have an extremely valuable treatise by Thomas Sully (1783–1872) written at the end of his long and active life which is a model of clarity and lucidity in explaining his methods. What makes his comments of particular value is that he was for a while the pupil of Sir Thomas Lawrence. He also knew most of the major English painters of the period. What he writes can therefore be taken as a reliable guide to the general practice of his time.

Sully states that he worked on a ground of middle tint made of white and black. This must refer therefore to an opaque mixture. He then proceeded to draw in the outline of the portrait in charcoal and heightened the effect with white chalk, using the colour of the canvas as the middle tint. If the time allowed, he also indicated the drapery (he gives the time of this sitting as around two hours, with five subsequent sittings of two hours each for the completion of the portrait). From this initial drawing on a canvas the likeness is transferred to another canvas at Sully's leisure, but this time it is drawn in with burnt umber, freely painted in a sketchy manner and as if using watercolour. It is not entirely clear from the text, however, whether this initial drawing is transferred from one canvas to another and if so why the original canvas could not be painted over in umber, for this does seem a needlessly repetitious process. The unfinished portrait of William Wilberforce by Sir Thomas Lawrence which I have carefully studied, entirely confirms all Sully's procedure, except that the charcoal and burnt umber drawing has taken place together on the same canvas. Elsewhere Sully mentions Lawrence was 'very exact and particular with the outline; more so than with any painter with whose process I am acquainted'. I would not personally regard the Wilberforce painting as carrying such a precise charcoal outline, although it may be considered to be fairly detailed. However the

interesting conclusion to be drawn from this is that the common practice must have been far more carefree, with much more being left to the *alla prima* stage. Sully does not mention how far the tone underpainting was taken and the tone of the sleeves in the Wilberforce portrait is mostly indicated with charcoal with an occasional touch of burnt umber superimposed.

Sully was so settled and confident in his procedure that to us today it seems somewhat mechanical. He recommends for example that on a portrait 76×63 cm (30×25 in.) that the corner of the eye be 24 cm ($9\frac{1}{2}$ in.) from the top of the canvas, provided it is a man and 25 cm (10 in.) if it were a woman, given that both were of average height. I have measured his canvases and can testify that he practised what he preached and indeed it seems to work perfectly well. Sully painted some forty portraits a year and he lived to be eighty-nine. It is perhaps not surprising that with such experience he could reduce the preparatory stages to such mathematical niceties.

If you believe that what was good enough for Sir Thomas Lawrence when he began a portrait is good enough for you, then the above will help you in establishing a procedure which you know was used by one of the last of the major English portrait painters and his pupils. There is one small point remaining about which there seems some ambivalence from Sully's account. Does one use charcoal, burnt umber or both to begin the drawing-in stage? It seems that Lawrence and Sully used both, and sometimes together. But my advice to beginners and students is always to employ burnt, or raw, umber over the charcoal for the simple practical reason that when you begin the colour stage you are less likely to lose your outline if you have to remove an unsatisfactory area with a rag and turps. Charcoal, even if fixed, is more likely to disappear for it is weak in tone and not bound with medium.

It is well known that the early Renaissance and Flemish painters employed an underpainting of egg tempera and this is still an excellent practice which I occasionally use myself. It also has the advantage of being quick drying so that one can commence almost immediately the next stage of the portrait. Egg tempera in tubes has a fairly short life and seems to harden after about six months. It is not difficult to make your own egg tempera but this would have to be used within a few days, so that unless you want to be a tempera painter and understand the behaviour of the medium fully, it does not really seem to be worthwhile. The only important thing to remember about the characteristic of the under-painting is that it should be lean and matt looking. For the chemistry of painting is no different in principle to that of the house decorator who is taught to paint fat over lean. Fat undercoats may contract or wrinkle faster than the top coat and thus produce cracks.

For this reason it is surprising that Sully mentions that he used 'no other liquid than a mixture of drying-oil and spirits of turpentine in equal quantities' but used sparingly. Theoretically this is not lean enough for the underpainting, if indeed it was used for that stage. Sully and all his contemporaries would have ground their own colour with a muller and the oil content would have been sufficient to make dilution with turps without oil quite acceptable, and, as we have said earlier, probably safer.

However, Sully's work does not seem to have suffered in any way except when he used bituminous pigment; the point therefore could be an over-refinement.

Casein colour and modern acrylics make excellent lay-in paint. So do the more recent alkyd colour. They also have the advantage of drying fairly rapidly (alkyd more slowly). I have occasionally used black watercolour as an *imprimatura*. This has been persuaded onto the canvas with difficulty by using a cloth and rubbing it in. Unfortunately the abrasion of the cloth may leave behind small particles of fibre on the canvas so that it is not a good practice; so whenever using a cloth to remove a wet area of paint, always take care not to rub too hard for this reason.

If the technical and optical reasons for underpainting, which I have explained, are set aside, it should be emphasised that a good draughtsman is always able to produce an able painting with the scantiest preparation. The unfinished portrait of M. Edmond Auguste Caro by Ingres in the Metropolitan Museum of Art, New York, seems to have only a thin pencil line as a guide but the paint has gone in unfalteringly, tone and colour fusing in just the right places. On one occasion only I painted a demonstration portrait and being pressed for time announced with a confidence that I did not feel that I would paint the sitter without any preliminary drawing whatsoever. I started with the flesh tint of the forehead and worked down and across painting tone and colour simultaneously. It is not one of my better portraits, but I hope I did not absolutely disgrace myself. The sitter plucked unexpectedly from the audience let it be known that he wished to buy the portrait and it is now in Germany. But I would never begin a commisssioned work with such brashness and still sleep at nights. So the message to all students at whatever level of accomplishment is only to undertake a portrait with the most painstaking preparation along the lines described. Over-confidence is no less a folly than its handmaiden timidity.

Overleaf
Portrait of the Architect, Desdeban Oil on Canvas Jean Ingres (1780–1867)
Musees de Besançon

This little known painting is probably as close as Ingres' got to an oil sketch. It is painted on a dark red ground which has been left intact in many places, such as under the collar. A ground of this darkness and brightness was unusual. The head has been beautifully modelled with just the right degree of reflected light under the lower jaw. The hair has been left blocked in with merely the locks indicated and ready to be taken to the next stage. There are signs from the lower part of the painting that the drawing was commenced in chalk, followed by umber outlines. The hand incidentally seems to be slightly too small, even allowing for natural differences

The alla prima stage

Alla prima means painting first time. The French use the phrase *un premier coup*, literally at the first blow, or stroke. In Churchill's studio at Chartwell, left more or less as it was when the great man died, is a painting which on the bottom left-hand corner is written *'touchez et laissez'*. On the other corner is the translation 'touch and leave'. Evidently a French painter had given such advice to Churchill who deemed quite rightly that it was important enough to write down. 'Touch and leave' could be a good translation of *alla prima*. Another phrase that might apply is 'the buck stops here'! For this is the stage at which you are truly on your own. If you draw, or underpaint, you can erase, erode, change or overwork as much as you wish and nobody will be the wiser. But in the overpainting every uncertainty, hesitation, lack of decision is there for all the world to examine, or at least the members of your local art group who are as likely to be even better informed.

Not all painters succeed in painting first time. The greatest make mistakes and rub out with a rag or blade and start again. Delacroix's fascinating 'Journal' is full of accounts of his struggle with areas that went wrong and that is why I think this diary is one of the closest accounts of what it actually *feels* like to be a painter, with the possible exception of the diary of that putative genius Benjamin Robert Haydon. Some of the Impressionist painters had problems with first time painting. Bonnard is said to have painted 'with a brush in one hand and a rag in the other'. I imagine that every painter probably dreams of painting everything first time and possibly many go to bed fretting over the passages that go wrong and dreaming of the ways that they can be put right. If you are in this category the situation is normal. But at least it is good to know that constantly to expect to get everything right is, of course, an impossibility which you will share with the giants. There is everything to be said for painting that takes a non-mechanical course in which chance also plays a role. There is a passage in Ruskin's *Elements of Drawing*,* in which he says that when you are painting well then chance is on your side. Only those who have struggled for technical mastery will appreciate the deep truth of this.

One of the best pieces of simple advice proferred to a young painter was that given by the English artist Mulready. He said, 'Know what you are about'. This means settling down to a routine or procedure. It is true that many great painters, including Turner, never established too set a practice. Nevertheless this is not in the beginning something to be imitated. Confidence can only grow with the repetition of an act and the constant use of a set palette. Unfamiliarity of routine, except in the hands of a master, can only produce insecurity in the hands of the beginner. With a portrait it is important therefore to settle down to a set palette of no more than the four or five colours I have discussed elsewhere, and

* Page 100, Dover Publication.

master these first. You will then find it comparatively easy to add to them and still keep the total palette under your control. A portrait, more than any other *genre* must be painted without undue labour. Preoccupation with a complex colour range is a hindrance to this. You may also on some occasions have to work quickly because your sitter is restless or even unco-operative, so that even if it is undesirable you may be forced to work under psychological tension, something which a still life or landscape will not burden you with. Again therefore, simplicity in the materials under your control will leave less to go wrong.

Supremacy of drawing
However much I have stressed the need for careful preparation and underpainting in a portrait there is, in the final analysis, no substitute for direct *alla prima* painting, which means in turn superlative drawing. No amount of knowledge of methods of the old masters, knowledge of old varnishes, recipes, secret mediums and formulae, if the stroke that is going to be there for all time, in pristine originality, does not go in the right place first time. Maroger's book '*Secret Techniques of the Old Masters*' was written to prove that the reason that no one can paint like Rembrandt any more was that we had lost the formula of a black oil, which consisted of linseed oil boiled with litharge and then mixed with mastic. Maroger produced a special buttery medium which he marketed in tubes based on this formula. Shortly after my art school days I painted a picture with this medium and with scientific diligence solemnly recorded on the reverse that it had been painted with Maroger medium. Alas, not even in the wildest rush of youthful vanity could I persuade myself that it had unlocked the secret of even the most obscure Dutch master of the kind that would just about make a second-rate auction room.

How to begin
Although your underpainting has established the portrait's tonality to your satisfaction it is still too early to begin painting the head *alla prima* fashion. It is best to rub in, or scumble, the background first. An indication that this was probably the practice of the eighteenth-century painters can be found from the double portrait by Reynolds in the Fitzwilliam Museum, Cambridge, almost completely painted apart from the heads (page 60). The reason why it is best and safest to begin with the background is that its colour can vitally influence the flesh tints to a surprising degree. It is best to keep the lay-in colour thin and fairly lean in case overpainting and later adjustment is required. The more experienced you become the more likely you are to arrive at your exact tone and colour with the first lay-in so that it requires no change. Gainsborough's backgrounds appear fairly thin and certainly are first time affairs; there is an oral tradition that he used a great deal of turpentine and this is borne out by the thinness of much of the paint. The hair of Gainsborough Dupont, for example, is painted like watercolour, is entirely monochromatic and is quite possibly the underpainting left intact. However the thinness or thickness of the lay-in of the surrounding areas varies from painter to painter and even painters who seem entirely settled in the methods will vary their practice. For instance, Rembrandt's

'*Philosopher*' in the National Gallery, London, has opaque shadow areas, certainly unusual, and made even more curious by dint of their being cold, almost blue grey. It is one of the important aspects of being familiar with paint that there is an appreciation of the difference between its opaqueness and transparency. In the methodology of what might loosely be called the classical tradition the distinction was familiar to all painters. Shadow areas were kept transparent in order to achieve maximum luminosity. (Early watercolourists even added more gum to the shadow areas to increase luminosity in imitation of oil paint practice.) Fortunately the low key and warm umber colours are all transparent and as these are normally employed for the underpainting, to begin with these can be left in the deep shadow areas relatively unadjusted. This is because, as I have discussed elsewhere, all deep shadows appear warm. From these deep shadow areas the key would be fixed for the half-tones and these would then be applied fairly loosely, so that they are dragged semi-opaquely into these darker regions. I think it is quite unlikely that this half-tone was dragged over the whole of the painting leaving the lighter areas to be painted on top, but I would make a distinction here between the lighter area and the highlight proper. It is far more likely, as we see in the half-finished Ingres, that half-tone and lighter areas *were mixed on the palette and painted and fused almost simultaneously on the canvas.* As further evidence of this a somewhat cryptic remark of Reynolds refers to the mixing of paint being accomplished on the canvas. This puzzled me for some time since one normally considers colour mixing as being carried out on the palette. What however he clearly refers to is the fusing of colour rather than the mixing of colour and this requires that ample paint be available on the canvas for this purpose.

The distinction between the light area and the highlight is important. In a portrait the highlight will usually occur on the bone and tip of the nose, as well as the forehead. The true local colour of the flesh will be found *next* to this highlight. This is so because if the light source is strong enough to produce a highlight it will then be also strong enough to change the local colour. The highlight will consist therefore of a combination of the colour and temperature of the light source mingled with the local colour. The light arriving next to the highlight will not therefore be so strong as to destroy the local colour but will be sufficient to reveal its true hue. This is not a new discovery for Eastlake described it over a century ago. It also corresponds to my own practical experience; nevertheless it was not until I read Eastlake that what I was doing crystallized into a guiding principle.

The halftones and flesh tints

I can now turn more to the practicalities. Having scumbled in your background you are now ready to begin *alla prima* fashion on the head. First mix your light flesh tint based on how it appears next to the highlight. An ample amount of this should be mixed with a palette knife and it should be constantly tested to see that it it correct. I use for this light red, ochre and white, although sometimes this might need to be varied and made cooler with black or viridian. But for most normal complexions you can certainly begin with this admixture. Simultaneously with this

tint I also mix my half-tone, that is the tone between your flesh colour and your deepest shadow, the latter normally occurring behind the ear or in the ear itself, or perhaps in the nostril. This half-tone on flesh is for beginners by far the most difficult and subtle tint that he or she will probably ever have to paint and in my experience produces the greatest despair. But it also produces the greatest exhilaration when it is right and the colours sing together and make the flesh truly alive.

In practice this half-tone assumes a grey-green, slightly olive aspect, normally most noticeable under the chin or side of the cheek. The reason this colour is so difficult for the novice to arrive at is in my view because it is totally unexpected! Grey-green is not the colour associated with flesh except in advanced cases of sea sickness. On the palette the colour appears even more improbable. A sample of Thames or Mississippi mud. Yet it works. And the reason is linked up with the role of complementary colour which normally modifies all local colours as they turn into shadow. I will almost invariably first apply my flesh tint to the forehead, bringing it downwards towards the cheek, and dragging it only slightly over the underpainted half-tones. These underpainted half-tones will then have laid over them the grey-green half-tones. If you are painting over an *imprimatura* of raw umber this can be allowed to filter through and influence slightly what is required.

Unusual optical effects
It is timely here to warn of an effect named after an English physicist called John Tyndall. If a semi-opaque colour is dragged over a darker one, the overlapping area will turn blue or blue-grey. The reason that the horizon is blue to us is that the air is full of motes and particles and these absorb the warm part of the spectrum and reflect the blue. All turbid substances that are semi-opaque behave in this fashion against a dark background and this is why our veins appear blue, our layers of skin behaving in the same way as layers of air. Similarly, cigarette smoke that is not seen against the light is a warm tawny colour, but turns blue against a dark background.

However when light shines through a turbid medium the reverse happens, as with cigarette smoke, and it appears warm. This can better be demonstrated by placing a small pack of thin white paper over a projected light. If you arrange for each sheet to be progressively shorter so that the light shines through increasing layers, the projected light changes colour from white through to yellow, then orange, until it finally appears red. It is for this reason that the setting sun appears redder than at noon by dint of the extra layer of atmosphere through which it is visible. It also explains why a transparent glaze over a white ground will be warmer than if the equivalent tone of that colour had been applied opaquely. For instance raw umber certainly looks a muddy non-colour on the palette and it will appear so if applied opaquely on the canvas. However, when applied thinly, such as in your underpainting, it assumes, a much hotter aspect, while burnt umber will become fiery.

Tyndall's Effect in painting accounts for a pink colour on your palette turning mauve on the flesh and giving your sitter the appearance of having a coronary problem. This is not something to bother about if your

See caption page 56

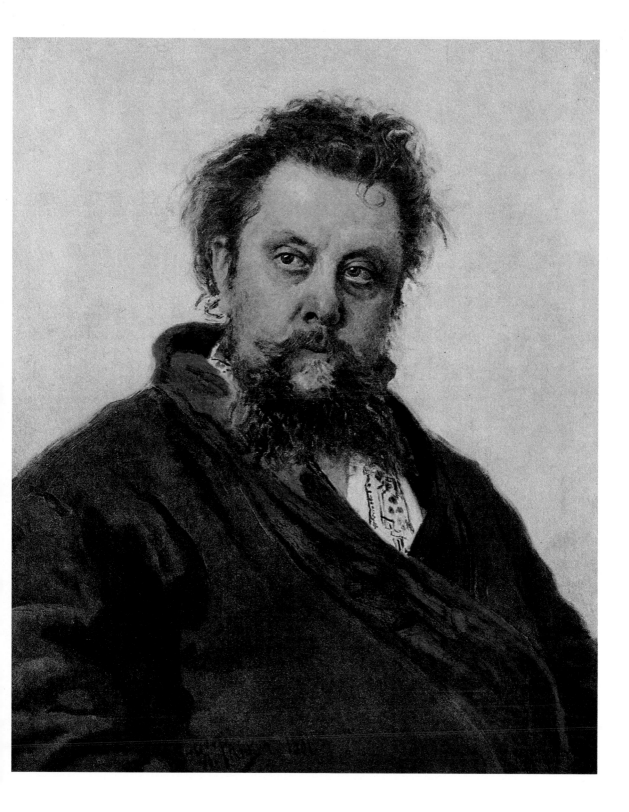

underpainting is approximately the same tone as the tone you are superimposing in colour. The darker the tone underneath, however, and of whatever colour, the more noticeable will Tyndall's Effect become, and I have noticed many students being baffled by what is happening on the canvas when they can see clearly that the colour they are using from their palette is warm.

There are three ways of dealing with this phenomenon. The first is merely to take it into account and allow for it. The second is to add a touch of ochre to your colour, in the case of flesh. This will counteract its tendency to become mauve as it is the complementary. The last, and easiest way to deal with it is to paint solidly and opaquely. It is for this reason it is not an effect which is noticeable in master portraits. However, the less dense quality of most modern tube paints, particularly the students' variety, will not have the covering power of the paint mixed in the early nineteenth-century by the painter himself who could control its density according to his taste. Naturally not all colours are dense; each varies according to its chemical component. But colour manufacturers while sometimes printing on the tube the chemical involved do not indicate the other materials that are also included and which are called fillers. These are usually of chalk or barite and are designed to extend the paint; but they correspondingly weaken its covering power.

You now have your portrait with the darks of the warm underpainting showing as accents, the cool middle half-tone and your flesh colour lying adjacent. These last two should now be gently fused together, gently and tenderly where the modelling demands. In the case of cheeks where there is not only a transition from cool shadow to warm flesh but the complication of a more intense pink, I have found that this can be introduced with a soft sable brush with almost pure vermilion or Indian red (depending on the complexion) and using the tenderest of strokes. The reason that one may use small amounts of such intense and pure colour is that it is immediately weakened by the existing colour on the canvas and is reduced in brightness; with care and experience it will assume precisely the right tint.

Painting in the wet

For all this to work it is clear that it must be done while the paint is wet.*
It is for this reason that I always try to paint my head virtually at one sitting of say two to two and a half hours. The eighteenth- and nineteenth-century painters went to great lengths to keep their paint wet and I imagine that with able draughtsmen this was always the practice. I do not mean of course that the canvas was running with oil but merely tacky enough to be malleable. The oil content needs to be kept quite low. Van Dyck's heads certainly testify to their being painted in this manner; such delicacy of fusion could not be accomplished in any other way. Such must

* It is of the greatest importance if the paint is to stay wet for the optimum time that the ground on which you paint is not too absorbent. Many of the painting boards now sold by artist's colourmen are of poor quality and soak up oil rapidly. Two coats of ordinary size will render them useable and non-absorbent. Modern white vinyl paint does not seem to work as a ground because it is absorbent. It is always safer therefore to use white lead primer.

See caption page 56

Henry James John Singer Sargent (1856–1925)
National Portrait Gallery, London
One would never believe that the painter of the celebrated American writer was carried out by the author of the epigram that a portrait is a painting with something wrong with the mouth. For here is a brilliantly painted mouth caught in suspended movement with apparent effortless ease. The portrait is unusual in having a low eye level which I would place somewhere around the hand. The impact of this on the observer is that he literally feels beneath the gaze of the sitter with all the psychological implications that this involves. The eye level of most portraits normally corresponds to that of the painter. Sitter-thrones were devised to avoid the subject being looked down upon

also have been the practice of Velasquez and Rembrandt, although with the latter's later work it is sometimes possible to detect areas that may have been picked up at later sittings. Most of the examples in this book were from single sittings inasmuch as they refer to the head alone. The self-portrait of Romney (page 87) which I have studied with some care, looks as though it were the result of no more than a morning's work. It is not that any of these painters hurried. On the contrary, nothing I am sure would persuade any of them to proceed faster than the rate that was natural to them. It was above all the sureness of their drawing. Nothing delays the execution of a portrait more than the continual rubbing out of incorrect passages of drawing. However, having said that, and indicating the dizzy heights to which we ought to aspire, everybody at some point scraped down, rubbed out or otherwise erased. No doubt the surer their draughtsmanship the less they did it. I find it hard to believe that Van Dyck re-touched anything. The thought is rather like contemplating spitting in church! Such a perfectly fused, colour modulated surface seems immaculate in its poise and infallibility. Nevertheless we can be sure that he re-drew and re-touched. Degas, Whistler and Sargent scraped down often to the canvas. A client of Sargent saw her head scraped down so many times she declared, 'Mr Sargent, you keep taking it off, and it always comes back the same'. Scraped-down surfaces are evocative and often stimulate the imagination. I remember a very early portrait which I was about to abandon because after some three sittings I was thoroughly dissatisfied with it. Before starting a fresh canvas I rubbed it with fine sandpaper. Magically a soft ethereal person appeared. A few touches and accents from memory and the head had been transformed. When presented to the client I believe the canvas weighed less than when I bought it from the art shop!
Although the artists I have mentioned are known to have scraped down, it hardly ever shows. Sargent's portrait of Henry James might well have been repainted many times for the paint is thick and textural. Artists, perhaps like politicians, are often very able at covering up their mistakes. 'To destroy', said Whistler, 'is to survive'. That is also a good way of covering up one's mistakes.

Highlights

Meanwhile back to our portrait, which now requires attention to the finer points of its modelling, perhaps refinement to the area around the cheek bone, and a deepening of the half-tone under the chin. Above all it will need the placing of the highlights. In my days as a student highlights were regarded with derision. Looking back it is difficult to find a rational explanation for the scorn they evoked. The nature and shape of a highlight is not only highly informative about the form but also the nature of its texture. It would be impossible to represent the surface of say, satin, if you were to ignore its highlights and it is difficult to see why flesh should be a special case in which the normal behaviour of light is suddenly suspended.

Highlights are not shapes with hard edges, but may have one hard edge and a series of soft edges. The shape and nature of the highlight must be carefully looked at if it is to explain the form. The highlight in an eye is an exception in that because of its aqueous surface the highlight may have all sharp edges, its shape reflecting that of the light source. The usual problem with the highlight however is less that of determining its shape than its colour. The principle elucidated by Eastlake applies and the great value of principles (when they are found to be reliable) is that they will always offer some theoretical guidance and suggest what the solution ought to be. According to Eastlake therefore, the highlight say, on the tip of the nose, will be a combination of the colour of the light source together with that of the pink flesh. If you are painting under a North light this will be cold or bluish and one would expect therefore the pink to turn slightly scarlet, that is, a cold red. This indeed can sometimes be the case. But in practice such highlights may give the portrait an outdoor look and may even look wrong. Rubens' highlights seem to have been yellowish, perhaps Naples yellow with white. Delacroix commenting on this decided that yellow highlights must be wrong. But they nevertheless look right and he could not explain this. Certainly Rubens' yellow highlights look right and I would venture the following explanation as to why this is so and indeed why it is my own practice to use them. Where one is dealing with a weak yellow, which such a highlight must be, it begins to take on a neutrality. If it is surrounded by pink or reddish hue its neutrality is affected and it will react as though it were a complementary. Thus it assumes a greenish cast.*

It was, and still is, excellent practice to apply the highlights thickly with laden paint to which the word *impasto* is given. Although by its nature the highlights must contain a large percentage of flake or titanium white, both weighty and dense pigment which will help the colour to stand up; *impasto* has possibly been used in the past for reasons other than the density of the paint. Paint thickly applied with a rich, intaglio surface becomes faceted and irradiates light almost like a diamond. Thus even when the correct tone of paint is applied the spectator receives a bonus of light which literally sparkles. Apart from this, thickly applied paint in all light areas generally provides for a variety of surface for the spectator

* The physiology of the eye is such that looking at a bright red light for some twenty seconds will produce an after-image of green, its complementary colour.

which helps to contrast with the flatter and more transparent paint. It was in this way that centuries of European tradition, provided no doubt by individual trial and error, developed the way in which oil paint could be exploited to the full, juxtaposing transparency and opaqueness and the ability of paint to become three-dimensional.

Sticking to a formula

The easiest way to ruin the highlight is to make it too chalky. This usually means that you have simply added white to your flesh colour and made no thermal adjustment. If after constant study of the highlight you are still unable to analyse its colour because of its minuteness, stick to your ochreish highlight and employ it as a formula. In a sense all painters, even those among the Impressionist painters whose methods were less consistent, employed a formula. Van Dyck's flesh tints, like those of Gainsborough always seem cool. His women look as though they have been locked indoors all winter without sight of the sun. Rembrandt's warm flesh tints are always identifiable and are consistent. Raeburn always employed the hottest colour so that his sitters irrespective of their individual characteristics seem sunburnt and glowing with health. Rubens' flesh tints always seem exaggerated with strong thermal contrasts of brightish pinks and cool greys and greens. Thus every painter in the end settles for a formula. If this were not so the style of painters would almost cease to be recognisable.

The word formula or system of course is off-putting and makes painting seem extremely pedestrian. But the exact opposite is the case. Once you have settled down to some kind of system you are more likely to have control over what is going on the canvas; this will increase your freedom of expression and not reduce it. With complete control over a limited palette the most precise and subtle range of effects can come within your compass. In the case of Thomas Sully's *Hints to Young Painters* not only did he recommend, as we saw in the chapter on underpainting, the number of inches the eye should be from the top of the canvas. His palette was also laid out in thirteen mounds of colour. Of these, five consisted of raw umber mixed with increasing additions of white (see overleaf). He then describes his precise manner of proceeding, thus:

> 'Cover all the forehead with the tint No. 2, and use No. 1 to increase the light on such parts as require it. The first light shadows will be Nos 2 and 3 mixed; make the blue tint, No. 3 more pure on the temple. The white of the eye, with Nos 2 and 3 and, perhaps, a little white. If it be a blue eye, use black and No. 3. In a delicate complexion the mixture of 2 and 3 may extend to the lower part of the face. No. 11 will increase the strength of the shadows and No. 10 will increase it further; No. 9 ditto, particularly where the shadows are of a cool tint. Perhaps the shadows in some places will require a warmer hue; then 12 and 13 will be found useful (they have a little burnt terra sienna tint in the raw umber tints). Having adjusted the shadows, a little vermilion can be scratched on the cheek and on the lips.'

As it is highly likely that Sully worked closely to the method employed by all early nineteenth-century painters, it is of extreme interest to have such a lucid account of his procedure. It looks remarkably close to that modern idea of painting by numbers! Nevertheless it tends to reinforce my own

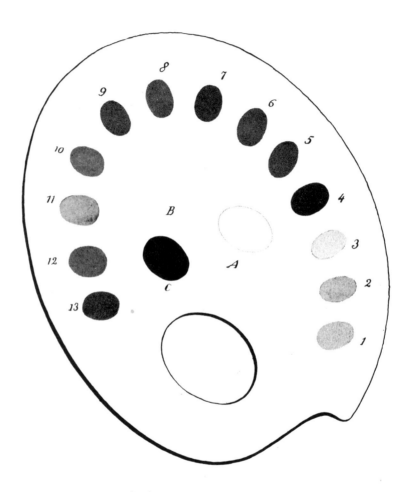

1. Yellow Ochre & White
2. Burnt Terra d'Sienna &White.
3. Ultramarine (or permanent blue &white.
4. Burnt Terra d'Sienna.
5. Chinese Vermilion.
6. Indian Red.
7. Raw Umber.
8. Raw Umber & White.
9. Raw Umber & more White.
10. Ditto do
11. Ditto do
12. Ditto with a little burnt T d'Sienna.
13. Burnt Terra d'Sienna & Raw Umber.
A. Flake White.
B. Yellow Ochre.
C. Ivory Black.

From *Hints to Young Painters* by Thomas Sully

view that constant practice to a specific end, which to Sully was a no-nonsense likeness will be aimed at eliminating unnecessary and often chancy procedures. 'No-one is an artist', wrote Monet, 'unless he carries his picture in his head before painting it, and is sure of his method and composition'. Although Monet may not have been as orderly in laying out his palette as Sully, it is clear that sureness of method is indispensable to spontaneous painting, and whoever the artist, it seems impossible, or at best, chaotic, without it.

Value of raw umber

Sully (or his printer) seems to have made a mistake and reversed the order of the tints 9 to 11 for these as described and illustrated would *decrease* the strength of the shadows. Their order should have been reversed. It is interesting to have confirmed my own view that raw umber, surely the most unpretentious colour on the whole of the palette, seems to have survived historically because of its value in creating directly the cool half-tones of the flesh and here described by Sully as being arrived at simply by the admixture of white. It is also worth noting that the white of the eye is arrived at with 2 and 3, demonstrating that it is warmer than it appears. With babies and children the white of the eye can be a delicate bluish egg shell colour. Increasing age produces discolouration of the cornea and this results in minute ochreish blotches changing the colour of this part of the eye. This can be missed if the student begins to paint the eye with the *idée fixé* that the white of the eye is white because the word says so!

The painter as physician

I have been interested in the overlapping area of portrait painting and medicine ever since a physician friend diagnosed a case of adenoids after studying a portrait of a red-haired boy I had painted. I later checked with the parents and found this was indeed a correct diagnosis, although I was quite unaware of an adenoids problem when I painted him. Experts seem to see only their own field or what interests them. A further extraordinary example of this occured when I asked an opthalmic surgeon why the outer edge of the iris was darker and seemed more heavily pigmented than the inner area. He seemed reluctant to believe it; so there and then with a pencil I drew him an eye, complete with highlight, to demonstrate what I thought I was seeing around the iris edge. A fortnight later he said to me, 'You were quite right. There is a darker ring round the edge of the iris'. As he had looked at many more eyes than I had, the conclusion seemed to be that his interest in the human eye was optical and pathological and that anything outside these fields did not arrest his attention.* To the artist, Velasquez's *Las Meñinas* is a piece of superlative painting. Many medical students, however, know it as containing a head that shows the ravages of congenital syphilis.

* Eye conditions and their connection with painting is discussed in *The World Through Blunted Sight* by Patrick Trevor-Roper. This fascinating account quotes I M Torrilhon as saying that Peter Breughel was the arch-diagnostician of eye-ailments. The five beggars in *The Parable of the Blind* have five identifiable eye diseases.

Light and the anatomy of the eye

Another attribute of the eye, of great importance to the painter, is the fact that it is translucent. This can lead to the following paradox. When the light strikes the iris at an angle the highlight appears to be surrounded by dark even though being round, that side is *facing the light*. The side opposite to the highlight however seems lit up, although it is in shadow. The reason for this contradictory process is that once the light has struck the surface of the eye and produced the highlight it still continues to pass through the eye and illuminates the other side because of the eye's transparency. The proper rendering of this effect gives the eye an aqueous and luminous quality, which is not available in any other way. Indeed it is possible to introduce this effect deliberately by changing the position of the highlight and transforming a dull eye into a live one. A study of Rubens shows that he introduced highlights into his eyes even when it was optically impossible, or when the light source was not even reaching the eye (eg *The Rape of the Sabine Women*). The employment of this device is therefore a legitimate conceit.

The lower lid

Perhaps the most difficult area of the eye to paint is the meeting of the white of the eye with the lower lid. I was first drawn to the Rembrandt Self-Portrait (opposite) because of the uncanny painting of the lower lid with all its colour changes and subtle stresses and tensions of form. The first thing to remember is that the eye is curving around and receding behind the lower lid, for it is a complete ball. The lower lid is projecting like a ridge and will quite often therefore appear slightly lighter because it is catching the light. Often when the white of the eye and lower lid meet at the point facing the light a tiny highlight occurs and this may occur on the outside edge of the lid. The problem is of course not to paint this so that it appears hard and I can only urge readers to study the way in which great masters handle this most difficult of areas while retaining the freedom and liquidity of paint that only consummate powers of drawing provide. The portrait of Van der Geest by Van Dyck contains a brilliant rendering of this area. It is quite possible to paint the lower lid without the detail my description suggests. The later Rembrandt and Velasquez managed it. So did Manet. But it is scarcely possible without a good knowledge of the anatomy of the eye, and perhaps going through the natural development of making many earlier renderings based on careful observation

The hair and the forehead

Another litmus test of master painting in the head is the rendering of the soft transition of forehead to hair. If badly painted it looks as though tufts of rug have been dropped from a great height on a glue base, or equally like the head of hair of a ventriloquist's dummy. As hair recedes from the forehead the multiplication of individual hairs increasingly check the visibility of the skin below until it finally disappears and it is this gradation, which is not necessarily regular, that represents the challenge of a transition to end all transitions. It is better that such an area always be painted in the wet and, in general the light dragged over the dark. It is

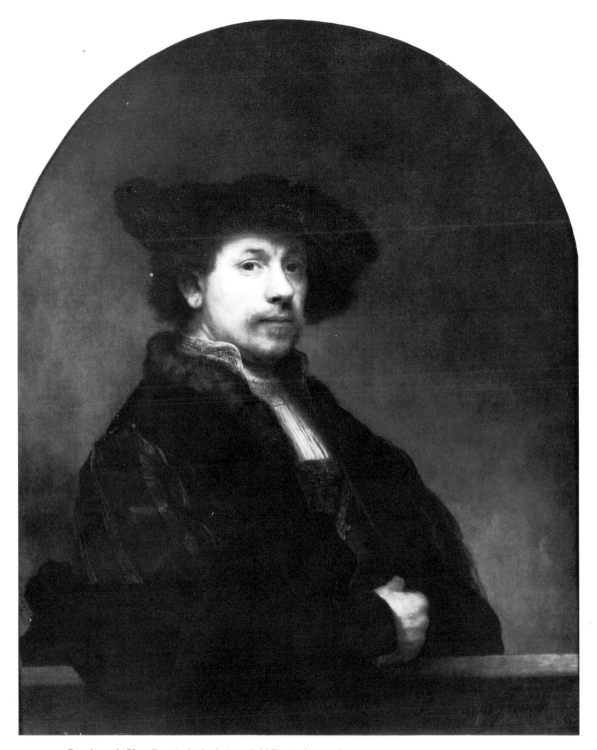

Rembrandt Van Ryn (1606–69) *Self Portrait* aged 34
National Gallery, London
Note how the strength of light falling on the coat is inconsistent with that
hitting the face, a deliberate and acceptable strategem to focus one's
concentration on the important area

always a problem in such a situation whether to know if such a transition is to be accomplished with two tones, namely, the tint of the forehead on the one hand and that of the hair on the other. In general it is better to achieve gradation by a series of separately mixed tones, provided it is feasible, than by two extreme tones that you somehow smooth or fuse together. In a letter Gainsborough refers to '. . . the touch of the pencil (brush) that is harder to preserve than smoothness', and goes on to add that it would be better if such things were noticed than an eye being a half inch out of drawing. There is no doubt that it is not possible to produce strokes and liveliness of modelling without separate touches of tone. Naturally much depends on how one wants to paint. Ingres' paint surface shows few if any touches of paint.

Final adjustments

The final stages of *alla prima* painting will consist of trying to look at your painting as a whole and correcting tonal errors, making colour adjustments, refining areas of modelling and strengthening the general effect with light glazes or small accents of dark. If you are in doubt about the general effect this will almost certainly revolve around whether you have managed to achieve proper values in your tonal range so that everything sinks into place and nothing jumps out. The simplest method of checking this is to place your canvas so that it faces your main painting room window and then slowly draw the curtain.* The reduction in the light simplifies the masses of light and dark and any area which is not in its right relationship is more quickly detectable. A similar effect can be achieved with the use of a Claude glass, a piece of plain glass that has been smoked or tinted. I have seen a piece of black reflecting plastic used for this purpose; because it is so dark only the pronounced light areas are visible and their correctness is easier established.

At the second sitting, or at any further stages of the painting which will require re-touching because of the likeness or because extensive areas still remain to be painted, it was the common practice to oil out. This would consist of rubbing a mixture of perhaps half oil and half turpentine over the whole with a rag. Because of the danger of excess oil it is a good plan to remove all surplus with a dry rag so leaving the surface merely moist. There has possibly been an over-reaction to oiling-out on the grounds that any excess of oil should be avoided. Thomas Lawrence was known to have oiled-out at each stage and there has been little noticeable yellowing in his work.

Where overpainting occurs it leads to sinking and mattness and should be corrected with re-touching varnish. This is not because there is any danger per se, but because the lowering of tone that a sunk area produces can lead to a misjudgement of the true tone if you are painting in an adjacent area; the tone you are applying will be full of oil and will change in tone as it sinks in turn. I use the simple expedient of spitting on my finger and rubbing any sunk area. This will immediately tell you the true tone by raising the refractive index.

* Gainsborough is known to have worked much in a darkened room, no doubt for the same reason.

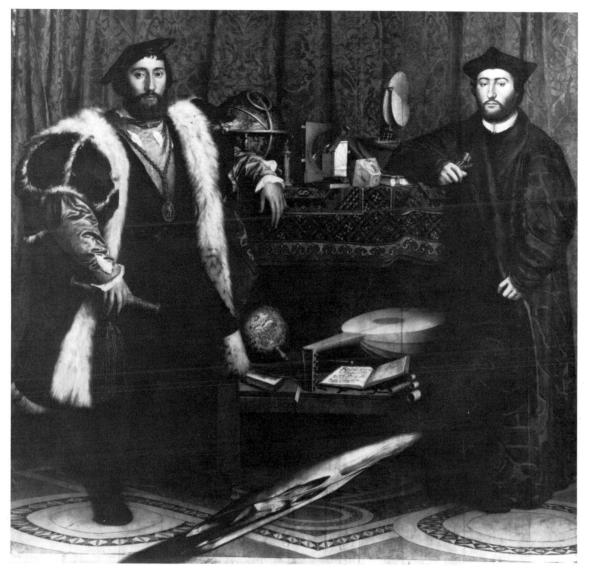

The Ambassadors Holbein (1497–1543)
National Gallery, London

I have included this well known work of Holbein to show how portraiture
may be widened in scope by including the objects and artefacts that
reflect the sitters' interests. This painting is particularly well known to
students of the history of science for its rendering of sixteenth-century
scientific instruments. Although the whole painting is full of the
humanistic rationalism of the Reformation the long cigar-shaped object
that is floating in the foreground seems out of character in its optical
surrealism. It is an elongated skull which assumes its correct shape when
foreshortened. Its presence has never been fully explained. It is likely that
it is more than an optical novelty to titillate the interest of these two
scholarly gentlemen, but is a visual pun based on the word holbein which
in German means skull or bone.

Van der Geest Anthony Van Dyck (1599–1641)
National Gallery, London
This is one of Van Dyck's most remarkable heads with its moist eye and
half open mouth on whose lip appears the barest glint of saliva, as though
caught in the act of speech.

To the student it presents a labyrinth of inexhaustible exploration. If we
follow the technical development of the painting we can see that Van
Dyck has directed his brush along the lines of the form. Thus the strokes
that form the lines of the lower lids and their bulges follow a parallel
course. On the forehead where the form is broader the strokes follow the
natural movement of the arm, from top right to bottom left. To the top left
of the forehead the strokes are almost vertical and this is consistent with a
right-handed painter's change of angle when approaching a left-handed
edge. The paint itself seems to be stiff and viscous yet at the same time it
has been kept manageable to the point where quite fine and delicate lines
are controlled such as can be seen in the hair. There is not one tiny region
of this head that has escaped the subtlest gradation and I doubt whether a
human hand will again achieve such mastery. As someone said of Van
Dyck . . . 'portraiture has been in decline ever since his death'

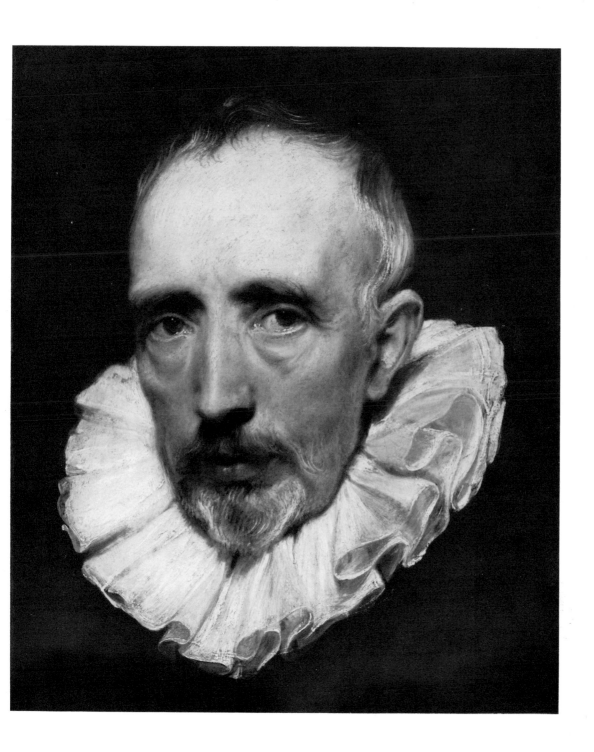

Self-portrait George Romney (1734–1802)

National Portrait Gallery, London

The brooding head that may have persuaded Emma Hamilton to sit so often and a painting that seems no more than a morning's work. It is direct, simple and apparently effortless yet ready if necessary to be advanced to its next stage. It appears to have been painted with scarcely any preliminary drawing, the hallmark of supreme confidence. Having studied this portrait carefully I am confident it was painted with only four colours, black, white, ochre and a red approximating closely to light red. Note the counterchange of tone behind the head of light against dark and dark against light

Self portrait Jacques Louis David (1748–1825)
The Louvre, Paris
This portrait by the painter and ideologist of the French revolution has always fascinated me not least because it was painted in prison. It is of some interest to the student of painting because it remains sketchy and incomplete, that is, on the standards normally set by David. Everywhere the umberish shadow of the underpainting has been left relatively untouched, such as in the hair, the shadow on the cheek and on the lapel and collar of the coat. Over this the local colour was opaquely and semi-opaquely introduced. This can be seen best on the coat sleeve where on its left the staininess of the transparent brush strokes can be clearly seen, and over which the opaque paint on the right produces a greater smoothness and absence of brush marks. The droop to the left of the mouth was evidently a physical deformity as this occurs in another portrait of David by a contemporary painter

Count Guriev Jean Ingres (1780–1867)
State Hermitage Museum, Leningrad
A fascinating example of how to make distinguished an exceedingly plain countenance and one that no doubt most portrait painters would approach with a sinking heart, if not a sense of dread. The total effect is due to an extremely artful and arresting design in which the brilliant scarlet lining splashes across the black cloak. Note as well how the lower pitch of the evening sky allows full attention to be focused on the light area on the face. The background is also full of interest without being obtrusive. This portrait is in Ingres' most Classical manner, yet it remains a liason of fact and artifice and one worthy of persistent study

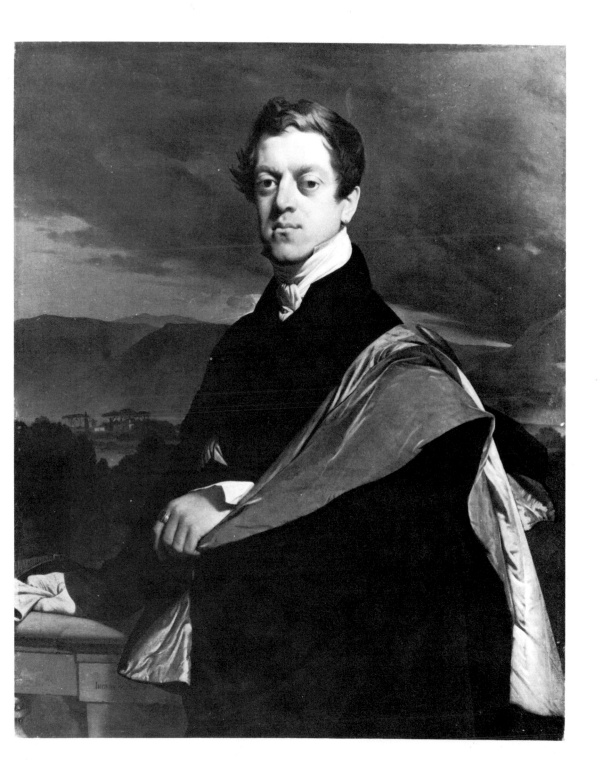

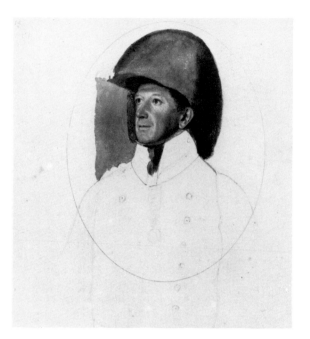

Sir Charles Alten

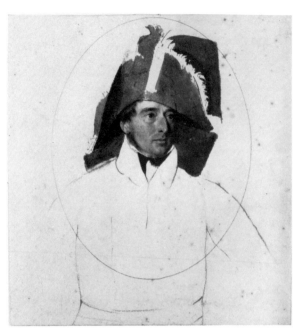

Sir George T. Walker

The fifth Duke of Richmond

Rowland Hill

Thomas Heaphy
National Portrait Gallery, London
These are undistinguished portraits and I have included them to show
what a run-of-the-mill portrait painter could produce at the beginning of
the last century and what fee he obtained. They are of Peninsula and
Waterloo officers and were painted on the battlefield. Even so the fee of
40 guineas, without the danger money, was as high as Reynolds and
Gainsborough were charging a few decades earlier. The events were
recorded in a private journal of the Judge Advocate to the British Forces.
He wrote: 'Oct 15th 1813. St Jean de Luz: Mr Heaphy the artist is here
and he has said that in consequence of these risks added 10 guineas to the
price of his likenesses and made them 50 guineas instead of 40. This is too
much for a watercolour whole length but he has I hear taken 26 and some
of them are excessively like'. 1813 for Mr Heaphy was clearly a very
successful year

Arthur Wellesely,
first Duke of
Wellington

Little Rose of Lyme Regis James A McNeill Whistler (1834–1903)
Courtesy Museum of Fine Arts, Boston
William Wilkins Warren Fund
This beautifully soft and atmospheric portrait contains the subtlest of
modelling of the head. It is of technical interest in that the canvas fibres
clearly show much evidence of scraping down on the area of the face and
by inference, that Whistler was dissatisfied with his initial renderings.
Whistler's silvery palette and the style of 'Little Rose' show often repeated
indebtedness to Velasquez. Apart from his painting Whistler was also a
formidable wit and his theories on art for art's sake were a strong
influence on Oscar Wilde. His views are entertainingly expounded in an
essay 'The Gentle Art of Making Enemies', his own account of his libel
action against John Ruskin in which he was awarded a farthing damages

Child in a Straw hat Oil on Canvas Mary Cassatt (1844–1926) *page 97*
National Gallery of Art, Washington DC
Collection of Mr and Mrs Paul Mellon
The charm of this delightful study is immediate and arresting. Cassatt studied in Paris where she came under the influence of Degas. Their regard however was mutual and Degas kept Cassatt's *Girl Arranging her Hair* in his collection until his death. Unlike other American *confreres* she returned to America during the Franco-Prussian war where she attended the Pennsylvania Academy. She remains the most remarkable of the women painters of the nineteenth century and few could fault the fresh spontaneous manner of this study which carries all the evidence of having been done without re-touching.
When I first saw *Child in a Straw Hat* in Washington's National Gallery there were five people in the large room of mixed paintings where it hangs all of whom were gazing at the portrait

Philip IVth Diego Velasquez Opposite
National Gallery, London
It was David who stated that "It is grey that makes painting", but it was Velasquez who had much earlier put the dictum into practice. The silvery tones in a Velasquez portrait are always immediately recognisable. This standing figure in the earlier tighter style of the painter is painted on a darkish warm transparent ground on which the decorative detail on the breeches seem to float in rich, loaded touches of highlight. Velasquez painted on a ground of white lead and which, according to A. P. Laurie,* was coated with a red ochre, a native red clay containing iron oxide. There is also excellent evidence that Velasquez sometimes underpainted with smalt (cobalt) and madder lake which produced a mauvish grey white. This was then glazed with an ochreish varnish to produce a warm glowing flesh tint.
* The Technique of the Great Painters p. 123

Christopher Oakeley Derek Chittock Overleaf
The subject of this painting sat almost immediately in the pose which is shown and it seemed natural and inevitable. There was only one minor change required. This was to move the hand on the left from its active position holding the axe which to a mountaineer would be face downwards. The present pose seemed more restful.
The strong light on the subject was obtained by narrowing my studio windows by drawing the curtains, something I had not previously done. The most difficult area to paint proved to be the rope which had developed definite bristly characteristics due to its passage against sharp granite rocks. However, these characteristics were important, for the rope had saved the lives of two climbers. Once I was told this, the rope took on a fascination that went beyond its pictorial importance and I was obliged to make a special effort to treat it with the same detachment as other parts of the painting.
The mountains in the background are the Dolomites which Christopher Oakeley has not as yet climbed. Until he does the background must be regarded as allegorical

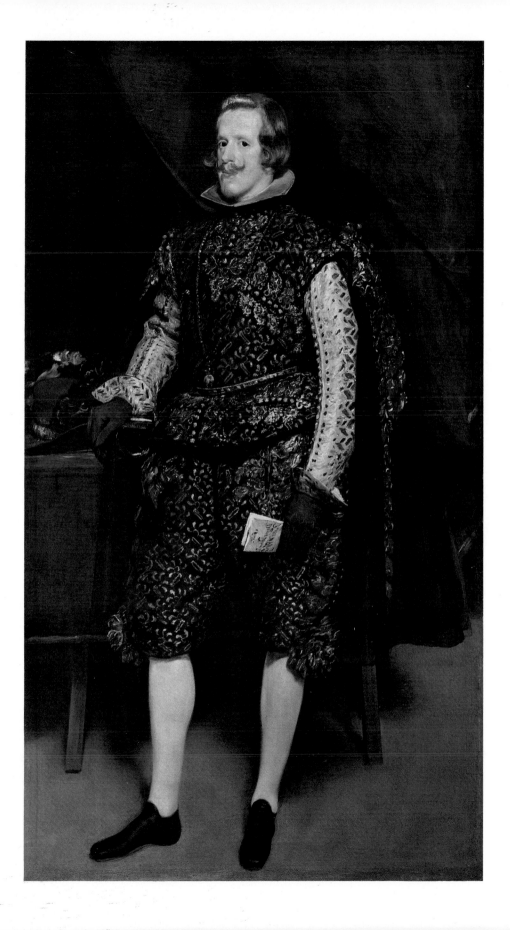

97

Bernard Shaw Augustus John (1878–1961)
Reproduced by gracious permission of Her Majesty Queen Elizabeth, the Queen Mother
This portrait might be described as an example of mutual obstinancy. As far as I am aware it is the only one ever painted with the sitter's eyes closed apart from the purely posthumous. Perhaps Shaw was bored with the whole proceedings and showed it; not to be up-staged John promptly painted him as he was, lids and all. Nothing could indicate more clearly how important is the sitter's cooperation in a portrait

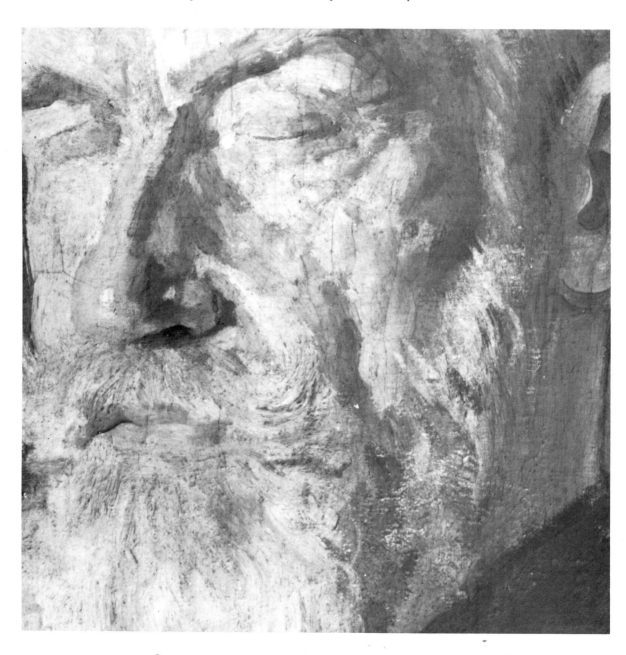

The Hon Mrs George Marten Pietro Annigoni (1910–)
In the Collection of *Mrs Martens*
The tight outline and soft modelling is closely in the manner of the early Renaissance and could almost be by Perugino or Antonello. The effect has been produced by the simplicity of the background combined with the lack of sharp shadows, an early Italian feature to which the word *sfumato* was given. Leonardo describes how gradated tones painted around the edges of windows could produce such lighting on the model. In the early fifteenth century hard-edged shadows were considered in bad taste. Like the quattrocento painters Annigoni also underpaints carefully and has reintroduced an oil egg emulsion as a vehicle. This can be made by taking a whole egg and shaking it with approximately twice its volume of oil in a Horlicks mixer. Varnish on the completed surface produces a greater luminosity of colour because it increases the refractive index

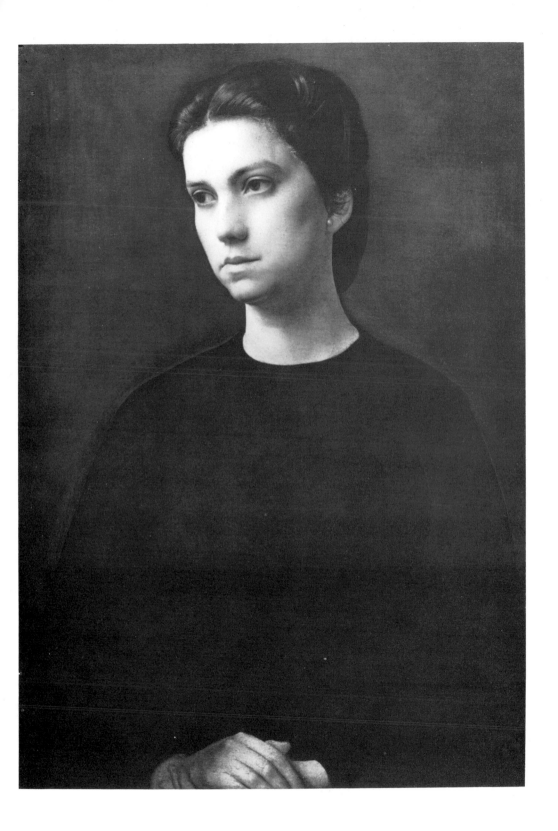

The Drifter Andrew Wyeth
Courtesy of Mr and Mrs Andrew Wyeth
Andrew Wyeth is America's best known painter although he remains too
little known in Britain. He is not only a painter of portraits but of
meticulously observed interiors and landscapes in the Brandy Wine
Valley region of Pennsylvania. Wyeth works in dry brush water colour, a
technique which he has made peculiarly his own, for, although he has
many imitators few have been able to realise his mastery with this
particular method. This remarkable head is painted in dry brush and
even in a small reproduction shows the fine attention to both the
character of the sitter and the textural resolution of the detail

Princess Anne Michael Noakes

As portraiture is bound more closely to tradition than most other forms of painting one has to search harder for smaller innovations. The style of Michael Noakes is innovatory and is immediately recognisable by its free spontaneous brushwork in which the record aspect of the sitter is never lost. The influence in his work stems from the modern impact of design and geometry which one could say was more traceable to Cézanne than to Degas. This relaxed and informal pose and the freshness of its treatment may be considered typical of Noakes' style

Effie Norman Hepple RA
Members of a painter's family are frequently the subjects of his finest portraits for he is behoven to none save his own pleasure and sense of mission. This timeless study of the artist's daughter, the subject of many paintings by Norman Hepple, has an immediate appeal. While softly modelled and resolved the drawing in the critical areas of the features is firm and cannot be faulted. The painting was carefully underpainted, according to Mr Hepple, in the manner of Reynolds

Aubrey Beardsley Jacques Emile Blanche
National Portrait Gallery, London
Blanche was a successful portrait painter towards the turn of the century.
Beardsley, the illustrator, knew Oscar Wilde and with his silver-topped
stick and carnation he seems to be apeing the great aesthete, although the
two men were mutually hostile.
It is an able enough portrait. I have included it because it is rare to
find a portrait in which the paint has been applied with almost total
transparency in the manner of watercolour. When overdone this can
produce staininess, and slight striations in the suit can be seen as a result
of this

Lord Denning, Master of the Rolls *Edward Halliday CBE, PRP*
Lincoln's Inn, London

This portrait brings to mind the simple direct lighting of the eighteenth-
and early nineteenth-century portrait. I have said elsewhere that light
from a single source is normally the best way to illuminate the head and
one can see here to advantage how it accents the main features without
complication. Halliday works on a canvas with a raw umber ground
specially prepared for him by Messrs Robersons. The tint of the umber
was arrived at after much experiment and is known as 'Halliday Special'.
It is cut from canvases of larger sizes as required. Where the bare canvas
with its ground shows through it appears next to the pink of the flesh as a
soft green and has the effect of acting as a cooling agent. Halliday's
interesting account of his procedure is as follows: 'I used to draw in black
conté on a white canvas, complete the drawing in Indian ink and then
with Ivory black and plenty of turps sweep all over it. Wiping away with
a soft cloth I removed nearly all the black to leave a light grey. This
removed the light grey and left the ink drawing only. This however in the
long run proved cumbersome, and the essential drying before painting a
waste of time: so, I evolved the 'ready-made' priming and raw umber
...'

Peter Ustinov Bernard Hailstone

Bernard Hailstone is a painter of long experience who has painted many people distinguished in public life. He is at his best when painting without over elaborate preparation and the vexing constraint that nearly all portrait painters feel over achieving the likeness. He then obtains great freshness of approach and colour. Hailstone describes the well known actor, playwright and raconteur as a restless subject liable to break into snatches of cod opera with the least provocation

Varnishing and hanging

When or whether to varnish a portrait is a question that frequently occurs. The new owner of a portrait tends to be a little anxious about its care and frequently expects it to be varnished almost immediately. Varnish that is applied too soon after the painting is completed, may, however form a chemical bond with the paint layer and therefore become irremoveable if it yellows at a later date. Even if it did not amalgamate chemically such early application of varnish would make its later removal more difficult for any future restorers as the varnish would tend to harden at the same rate as the oil film. The removal of varnish is made easier because as oil paint ages it also hardens and becomes more impervious to solvents. The paint layer of sixteenth-century paintings is extremely hard and the dissolution of a much later varnish layer is a skilled but relatively simple operation. The main purpose of varnish is to provide a protection against moisture and gases, from direct touch and scratches, and also to bring out the depth and transparency of the colours. Varnish normally lasts about twenty years before beginning to degenerate.

It follows that varnishing should be left for as long as possible to avoid 'cross-linking' or chemical amalgamation. The actual application of varnish is done by professional restorers with an electric spray gun and is kept thin enough just to bring out the full colour saturation. Surface dirt should be removed if the painting has been left long enough for any to accumulate, but not with soap and water. Better is gum turpentine and wiping down gently with gauze. Turpentine has a mild solvent action but this should be quite safe provided many months have elapsed; water can penetrate to the glue priming and loosen it. The older practice of warming varnish before applying it has been proved by experiments at the National Gallery, London, to be correct. Dust and particles in the air are irritating when varnishing as they can be when painting outdoors. I like the story recounted by Dr Ruhemann, of the restorer at the Berlin State Gallery who in despair varnished his pictures on a boat in the middle of a lake to avoid floating fluff.

Some practices here, such as the use of a spray gun, are councils of perfection, and nothing terrible is likely to happen to your portrait if you lay your painting flat, to avoid 'curtains' developing, and apply picture mastic varnish with a broad soft brush. Oil should not be included in any varnish medium. This was a practice in the nineteenth century when a golden tint was also introduced (called the 'gallery tone'), but the difficulty of removing it later was much increased because of the hardening of the oil. The question of picture varnishes and picture conservation generally is highly technical and reading specialist books and articles by experts employed by State galleries can undermine confidence to the point of paralysis. It is extremely important therefore to keep a sense of proportion and not be too blinded by science. Master paintings have survived for centuries without the lofty standards now laid down by museum journals and UNESCO for their conservation. These standards are no doubt appropriate for the resources of national

collections but it would be unrealistic and unnecessary to apply them to a recent painting.

Hanging a portrait

Advice on hanging a portrait is sometimes sought, although often the spot where it is intended to be placed has already been decided. There is, theoretically, a 'correct' viewing distance of a portrait and this should place the spectator in the same position *vis-a-vis* the perspective of the subject as was the artist. However, I cannot say that not being in the right viewing position has ever undermined my appreciation of a Rembrandt. In 1820 Sir Thomas Lawrence wrote a letter to a Mr and Mrs Gilmore of Baltimore, which accompanied two portraits he had painted of them. 'If, before they are hung up,' he related, 'you wish to show them to your friends for their inspection, let them be so placed that the light may fall upon them from the *left* of the spectator, (no matter on which side it appears to come in the picture,) and forming an angle to that light.' This very interesting observation would have made excellent sense had the remark in parenthesis not been included. If the paint surface is viewed in a light which arrives from the opposite direction from which the subject of the painting was carried out the spectator can be deceived into believing that convex paint on its surface is concave.* The implication of this is that a painting ought always to be viewed with the light source coming from the same direction as it appears in the painting. In the light of this knowledge Lawrence's remark in brackets is misleading, which illustrates that picture hanging may be more complicated than it often appears. However if the principle as outlined were practised *ad absurdem* all paintings in a room with one window would have to hang on the same wall.

* For an account and illustration of this curious phenomenon see Helmut Ruhemann's *The Cleaning of Paintings* published by Faber (page 112).

Bibliography

Antal, Frederick, *Florentine Painting and it's Social Background*, Routledge
Antal, Frederick, *Hogarth*, Routledge
Blunt, Anthony, *Artistic Theory in Italy*, Oxford
Cellini, Benevenuto, *Autobiography*
Delacroix, Eugene, *Journal*, Phaidon
Doerner, Max, *Materials of the Artist and their Use in Painting*, Harrap
Dunstan, Bernard, *Painting Methods of the Impressionists*, Watson-Guptill
Eastlake, Sir Charles, *Methods & Materials of Painting of the Great Schools and Masters*, Dover
Gainsborough, Letters of, Lion & Unicorn Press
Goldwater, Robert and Treves, *Artists on Art*, John Murray
Gordon, Louise, *Drawing the Human Head*, Batsford
Gordon, Louise, *Anatomy and Figure Drawing*, Batsford
Hardie, Martin, *Water Colour Painting in Britain*, Batsford
Holt, Elizabeth, *Literary Sources of Art History*, Princeton University Press
Laurie, A P, *Painter's Methods and Materials*, Seeley, Service and Co.
Laurie, A P, *The Technique of the Great Painters*, Carroll and Nicholson
Lindsay, Jack, *Turner: A Critical Biography*, Adams and Dart
Maroger, Jacques, *Secret Formulas and Techniques of the Old Masters*, Studio
Millais, J G, *Life and Letters of Sir Edward Millais*, Methuen
Ruhemann, Helmut, *The Cleaning of Pictures*, Faber
Roper, Patrick Trevor, *The World through Blunted Sight*, Thames and Hudson
Scharff, Aaron, *Art and Photography*, Pelican
Sully, Thomas, *Hints to Young Painters*, Reinhold, New York
Rosenau, Helen, *The Painter J-L David*, Nicholson and Watson
Ruskin, John, *Elements of Drawing, Dover*
Hauser, Arnold, *The Social History of Art*, Routledge
Watson, Lyall, *Super Nature*, Corgi
Wilenski R H, *Dutch Painting*, Faber
Wilenski R H, *English Painting*, Faber
Waterhouse Ellis, *Reynolds*, Phaidon
Thraliana, *(Ed) Balderston*, Oxford
Wain, John, *Samuel Johnson*, MacMillan

Suppliers
Great Britain

Artists' materials

Crafts Unlimited
(Reeves-Dryand)
178 Kensington High
Street, London W8

11–12 Precinct Centre
Oxford Road
Manchester 13

202 Bath Street
Glasgow C2

Dryad Limited
Northgates
Leicester LE1 4QR

L Cornelissen and Sons
22 Great Queen Street
London WC2

Clifford Milburn Limited
54 Fleet Street
London EC4

Reeves and Sons Limited
Lincoln Road
Enfield
Middlesex

Robersons and Company
Limited
71 Parkway
London NW1

George Rowney and
Company Limited
10 Percy Street
London W1

Winsor and Newton Limited
51 Rathbone Place
London W1

United States

Artists' materials

Arthur Brown and Bro Inc
2 West 46 Street
New York, NY 10036

A I Friedman Inc
25 West 45 Street
New York, NY 10036

Grumbacher
460 West 34 Street
New York

The Morilla Company Inc
43 21 Street,
Long Island City
2866 West 7 Street
Los Angeles, California

New Master Art Division
California Products
Coporation
169 Waverley Street
Cambridge' Massachusetts

Stafford-Reeves Inc
626 Greenwich Street
New York, NY 10014

Steig Products
PO Box, 19, Lakewood
New Jersey 08701

Winsor and Newton Inc
555 Winsor Drive
Secaucus, New Jersey
07094

See Yellow Pages for your nearest Artists' Colourmen

Index

Accidents (chance), role of 69
Acrylic 67
Adenoids, identifiable in
 portrait 79
Air, turbidity of 39
 pollution of 39
Alkyd 67
All prima 30, 31, 62, 66, 69,
 70, 71, 82
Andreada, Sir Diego d' 25, 26
Artefacts 9, 83
Arts Council 40
Atelier 37

Beaumont, Sir George 14
Biologists, Soviet 43
Brandy Wine Valley 103
Brown, Cassels 62
 Van Dyck 62

Casein 67
Chalk, as extender 73
 white 63
Chartwell 69
Chroma 31
Churchill, Lady 26, 27
Counter-change, of light and
 dark 12, 37, 86

Daguerre 52
Daguerrotype 10
Dartmouth, Earl of 26
Darwin, Charles 10
Driberg, Tom 14

Elizabeth I 9
Emulsion, egg 100
Eye, anatomy of 80
 discoloration of white of 79
 diseases of 79
 highlights in 76
 iris of 43
 pupil 43

Flanders 7
Flesh tint, blocking in of 63
 its true colour 71
 of Boucher 31
 of Gainsborough 77
 of Raeburn 77

of Rembrandt 77
of Van Dyck 77
of Rubens 77
Fresco, Giotto 7

Gilmore, Mr & Mrs 115
Glazing 60, 63
Greeks 7
Ground 63
 of Ingres 67
 absorbent 73, see vinyl
Guild of St Lucas 26

Hanseatic League 9
Henry VIII 9
Highlight, colour of 76
 in eye 35
 shape of 76
 chalkiness of 77

Iconography 9
Impasto 76
Imprimatura 62
Iris 43
Italy 7

Laurie, A. P. 96
Light, north 37
 cross light 35
 single source 35
 fluorescent 39
 tungsten 39
Literalism to be avoided 37
Lock, Adriaen 25

Maroger 70
Medallion 7
Meninas, Las
 79 see Velasquez
Monochrome 63
Mouth, difficulty of painting 41

Newgate 10
Nose, Gilbert Stuart's view of 41
 of Mrs Siddons 41

Oiling out 82
Origin of Species, Darwin 10
Osram 39
Overpainting 69 see alla prima

Paint acrylic 67
 casein 67
 alkyd 67
 its opaqueness 71, 77
 its transparency 29, 71, 77
Painting, first time, alla prima
 69
 in the wet 73
Palette curiosity about 32
 set 73
Palette knife 71
Peruzzi Chapel 7
Petsworth 25
Philosopher, The
 71 Rembrandt
Pupil, of eye 43

Reformation 9, 83
Renaissance 9, 66
Roberson's 110
Roper, Trevor P 79
Ruhemann, Dr H 115

Sandpaper, use of 74
Science Museum, London 49,
 51, 54
Scumbling 71
Sfumato 38
Shadows, luminosity of 71, 77
Sinking, effect on tone, 82
Size, glue 73
Spanish Royal family 14
Spectrum 39
Stereoscopy, use of 54
Studio 37
Surrealism 83
Syphilis 79

Theatre, sense of required in
 portraiture 17
Thrale, Mrs Hester 10
Torrillon 79
Turbidity, of air 39
Tyndall's effect 72
Tyndall, John 72

Umber, raw, value of 77
 as underpainting 58, 62

Vinyl, as unsatisfactory paint
ground 73

Washington DC 39
Water colour, as imprimatura 67

Windows, effect of 35
used by Leonardo 38

Index to Artists and Paintings

Alten, Sir Charles Thomas
Heaphy 92
The Ambassadors Holbein 8, 9, 83
Anne, Princess Michael Noakes
105
Annigoni, Pietro, *Hon Mrs George
Marten* 101
Antonello 98
Arnolfini Van Eyck 9

Bacon, Francis 14
Baretti, Guiseppe 10
Beardsley, Aubrey Jacques Emile
Blanche 108
Beechey, Sir Thomas
Mrs Siddons 10, 12
Birley, Sir Oswald 25
Blanche, Jacques Emile
Aubrey Beardsley 108
Boucher 31
Breughel, Peter 74, fn 79
Brouwer 10
Burke, Edmund Reynolds 60

Canaletto 49
Carlyle, Thomas Whistler 54
Caro, M Edmond 67
Cassatt, Mary *Child in a straw hat*
96, 97
Cellini, Benevenuto 7
Cezanne, Paul influence on
Michael Noakes 104
Chadburne, Claude 55
Chittock, Derek 18, 19, 58, 59,
and colour plates facing
pages 73 and 97
Churchill, Sir Winston 26, 27,
69
Claude 82
Cromwell, Oliver 8

Dance, George 37
Dante 7
Dartmouth, Lady Gainsborough
26

David, J L 88
Degas 52, 56, 74, 104
Delacroix, Eugene 76
Delaroche 52
Denning, Lord Edward Halliday
110
Derby Day W P Frith 17
Desdeban Ingres 67, 68
Devis, Arthur, 17
Devonshire, Duchess of 14
Dilletanti, Society of 20–3
Doerner, Max 63
Drifter, The Andrew Wyeth 103

Eastlake, Sir Charles 71, 76

Farnese, Cardinal 9
Frith W P 17

Gainsborough, Thomas 10, 26,
34, 41, 63, 64, 70, 77, 82, 93
Gaitskell, Hugh Richard
Hamilton 40
Giotto 7
Gisz, George Holbein 9
Goya 14
Guriev, Count Ingres 56, 90

Hailstone, Bernard *Peter Ustinov*
112
Halliday, Edward *Lord Denning*
110
Hals, Frans 17
Hamilton, Richard
Hugh Gaitskell 40
*Harris, Mr & Mrs Richard &
family* Derek Chittock 18
Haydon, B R 69
Heaphy, Thomas *Sir Charles
Alten; Rowland Hill; Duke of
Richmond; Sir George T
Walker; Arthur Wellesely, first
Duke of Wellington* 92, 93
Herkomer, Hubert 53
Herschel, Sir J 51

Hill, Rowland 92
Hilliard, Nicholas 9
Holbein, *The Ambassadors* 83

Ingres, *Count Guriev* 56,
Desdeban 67, 68, 90

Jagger, David 52, 54
John, Augustus 15, 98

Lawrence, Sir Thomas 10, 28,
36, 64, 66, 82, 116
Lee, Vernon Sargent 42
Leonardo 8, 37, 49, 100
Lovat, Lord 14

Manet, Edouard 33, 80
Marten, Hon Mrs G Annigoni 98
Mellon Sir Oswald Birley 25
Mendoza, June *The London
Business Schools Academic
Committee* 24
Menzel 56
Michaelangelo 63
Millais, Sir J E 45
Miranda Derek Chittock 58
Monet 79
Mulready 69

Noakes, Michael 104
Norman, Montagu Augustus
John 15

Parable of the Blind Peter
Breughel 79
Perugino 98
Phillip IV 8, 96, and colour
plate facing page 96
Porter, Sir George Bernard
Dunstan 33

Raeburn 77
Rape of the Sabine Women
Rubens 80
Rembrandt 1, 8, 25, 28, 32, 36,

70, 74, 77, 80, 116
Repin, *Mussorgsky* 8, 56 and
 colour plate facing page 72
Reynolds 10, 35, 48, 49, 50, 60,
 63, 70, 71, 93
Richmond, Duke of Thomas
 Heaphy 92
Rigaud 11
Romney 28, 74, 86
Rubens 62, 76, 77, 79
Ruskin, John 41 fn, 69, 94, 99

St Francis 7
Sargent, J S Henry James 41, 42,
 74
Shaw, Bernard Augustus John 98,
 99
Sickert 52
Siddons, Mrs Sarah Beechey and

Reynolds 10
Spear, Ruskin 14
Spurzeheim, Dr Cornelius
 Varley 51
Stuart, Gilbert 41
Sully, Thomas 30, 36, 64, 66,
 77, 79
Sutherland, Graham 26

Turner J M W 11, 25, 69

Ustinov, Peter Bernard Hailstone
 112

Van der Geest 80, 84, 85
Van Dyck 17, 64, 73, 74, 77, 80,
 84
Van Eyck 9
Van Ostade 10

Varley, Cornelius 50
Varley, John 50
Velasquez, 8, 33, 80, 96, and
 colour plate facing page 72
Vermeer, 35, 49

Walker, Sir George Thomas
 Heaphy 92
Walton, John Claude
 Chadburne 54, 55
Washington, George 40
*Wellesely, Arthur, first Duke of
 Wellington* Thomas Heaphy
 92
Whistler, J Mc N 53, 74, 94
Wilberforce, William Sir Thomas
 Lawrence 28, 66
Wyeth, Andrew, *The Drifter*
 102, 103